metadata

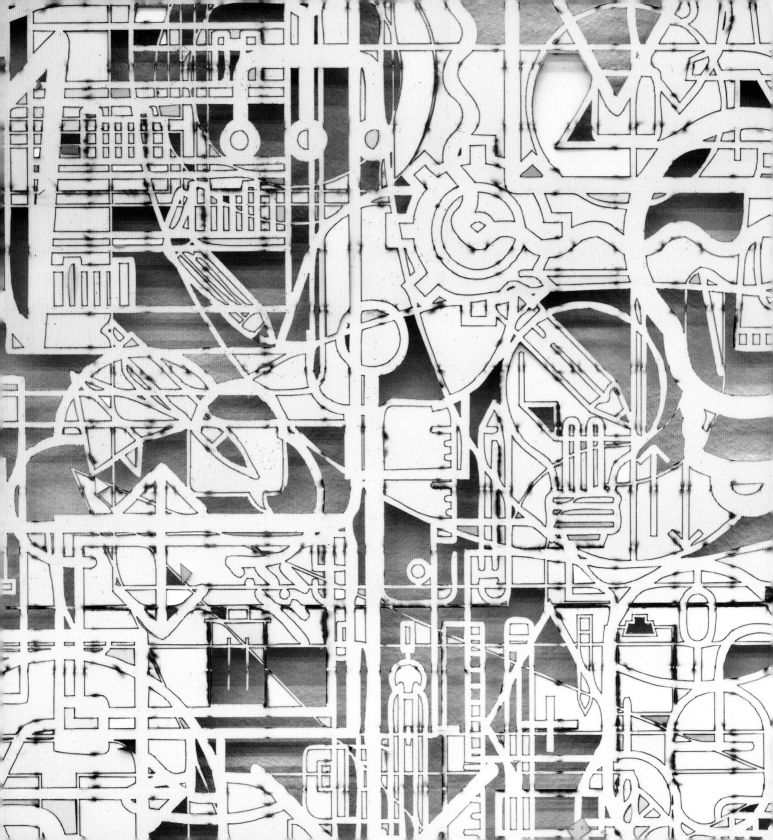

metadata

Rethinking Photography in the 21st Century

THE JOHN & MABLE RINGLING MUSEUM OF ART

STATE ART MUSEUM OF FLORIDA | FLORIDA STATE UNIVERSITY

Funding for this exhibition and publication is made possible through support from the National Endowment for the Arts; the State of Florida, Department of State, Division of Arts and Culture; and the Florida Council on Arts and Culture and paid for in part by the Sarasota County Tourist Development Tax revenues. Additional support is provided by the Gulf Coast Community Foundation and The John and Mable Ringling Museum of Art Endowment.

Title page: Lilly Lulay, *Our Writing Tools Take Part in The Forming of Our Thoughts, F* (detail), 2018, laser-cut inkjet print, 45 × 60 cm. Courtesy of the artist and Galerie Kuckei + Kuckei, Berlin

Opposite: Trevor Paglen, *Machine Readable Hito* (detail), 2017, adhesive wall material, 490.2 × 140 cm. Courtesy of the artist and Metro Pictures, New York

First published in 2022 by
Scala Arts Publishers, Inc.
c/o CohnReznick LLP
1301 Avenue of the Americas
10th Floor
New York, NY 10019
USA
www.scalapublishers.com
Scala—New York—London

In association with
The John & Mable Ringling Museum of Art
5401 Bay Shore Road
Sarasota, FL 34243
USA
www.ringling.org

Distributed outside of the John & Mable Ringling Museum of Art in the book trade by
ACC Art Books
6 West 18th Street
Suite 4B
New York, NY 10011
USA

ISBN 978-1-78551-375-6

Edited by Magda Nakassis
Designed by Studio A, Alexandria, VA
Printed and bound by 1010 Singapore

Library of Congress Cataloguing-in-Publication Data. Names: The John & Mable Ringling Museum of Art, organizer, host institution, author. | Jones, Christopher. Title: Metadata: Rethinking Photography in the 21st Century. Description: The John & Mable Ringling Museum of Art, Sarasota, Florida : In association with Scala Arts Publishers, Inc. New York, 2022. | Exploration of the transformation of the photographic image through art. Featuring international artists Mohsen Azar, Viktoria Binschtok, Mladen Bizumic, Joy Buolamwini, Ali Feser and Jason Lazarus, Rafael Lozano-Hemmer, Lilly Lulay, Trevor Paglen, and Penelope Umbrico. Curator Christopher Jones. Accompanies the exhibition at The John & Mable Ringling Museum of Art, Sarasota, Florida. Identifiers: LCCN 2021917361 | ISBN 978-1-78551-375-6 (pbk.) Subjects: LCSH: Art, Photography John & Mable Ringling Museum of Art—Exhibitions | Art—Florida (State)—Catalogs. Classification : 2021917361

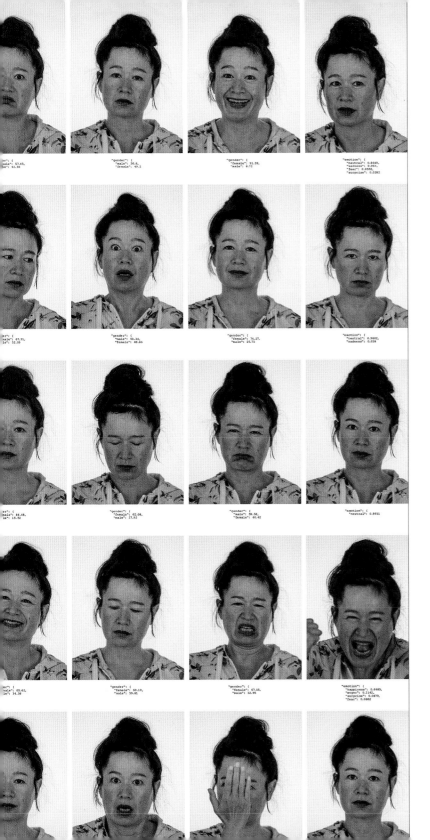

Contents

Director's Foreword

Metadata: Rethinking Photography in the 21st Century marks the opening of a new chapter for The John and Mable Ringling Museum of Art. It is the first major exhibition of contemporary artists to be organized as part of our newly inaugurated Stanton B. and Nancy W. Kaplan Photography and Media Arts Program. The program, founded in 2019 by the Kaplans, is part of a gift that includes an exceptional collection of nineteenth- and twentieth-century photography, as well as support for an endowed curatorship. This builds upon the museum's history of exhibiting and collecting photography, a practice that began sixty years ago, at a time when acceptance of the medium by fine art museums was not yet universal, demonstrating The Ringling's long-standing willingness to break new ground. In recent years, the museum has increasingly presented innovative and experimental artists who work in video, digital, and other forms of media, as part of our contemporary art program. This new program and curatorship envision a collection that will educate our audiences not just on the history of artists working in photography, but also the ways artists have used the evolving technology to create new kinds of images, to represent new subjects, and to present new ways of seeing since photography's invention nearly two hundred years ago.

This ambitious exhibition brings to Sarasota's community an international selection of artists who represent the forefront of critical thinking about the legacy of the photographic image and the nature of its current digital, networked, and increasingly automated forms. Among these artists are Rafael Lozano-Hemmer and Trevor Paglen, two of the most recognizable names in the global context of contemporary art, each of whom have recently had major mid-career survey exhibitions. United States–based artists Jason Lazarus and Penelope Umbrico, along with European artists Viktoria Binschtok, Mladen Bizumic, and Lilly Lulay, are all radically expanding the boundaries of what photo-based practice can be and are deepening our thinking on the medium. Offering an interdisciplinary voice to this conversation is computer scientist and "poet of code" Joy Buolamwini, whose work exposes racial and gender biases in artificial intelligence. This exhibition continues The Ringling's commitment to supporting emerging artists and commissioning new artworks; we are pleased to present Mohsen Azar in his first major US museum exhibition and his work *As of Now...*, which has been commissioned for the museum's collection. Additionally, we will unveil a new, site-specific installation entitled *Man and God*, created for this exhibition by Jason Lazarus in collaboration with the anthropologist Ali Feser, who has also contributed to this catalog an essay based on her original research on the Eastman Kodak Company. Collectively, these artists represent a diverse range of perspectives on the social, political, and ontological aspects of the technological image in contemporary culture.

We could not realize this important exhibition, or any of our other endeavors, without the contributions of our entire museum staff. In light of the adversity of the global pandemic, only beginning to wane as this publication is set out to print, each of The Ringling's employees deserves commendation for their hard work, sacrifices, and commitment to the museum's mission. Because of their dedication and perseverance, we were able to continue serving our community even through the most difficult times of the lockdown. I would like to congratulate Christopher Jones, this exhibition's curator, in his role as the

LEFT
Viktoria Binschtok, *Bottle, Bulb, Bump* (detail), from *Cluster* (2014–2017), 2017, three digital C-prints, 80 × 110 cm each. Image courtesy of the artist and KLEMM'S, Berlin

first Stanton B. and Nancy W. Kaplan Curator of Photography and Media Arts, and applaud his scholarship, creativity, and enthusiasm, all key in stewarding this collection and developing innovative exhibitions such as this one. My deep thanks go to our registrars and preparators who have worked diligently to ensure that this and all of our exhibitions meet the highest standards. The team at Scala Arts Publishers has once again produced an exceptional exhibition catalog and have been wonderful collaborators throughout the process.

Our exhibitions program would not be possible without the support of our museum members, who enable our curatorial programs at The Ringling, and our sponsors. This exhibition is supported in part by the Gulf Coast Community Foundation and The John and Mable Ringling Museum of Art Endowment. We are immensely grateful for the bedrock of support from our local community and the continued stewardship of Florida State University.

Steven High
Executive Director
The John and Mable Ringling Museum of Art

Acknowledgments

First and foremost, I want to offer my thanks to all of the exhibition's artists: Mohsen Azar, Viktoria Binschtok, Mladen Bizumic, Joy Buolamwini, Ali Feser, Jason Lazarus, Rafael Lozano-Hemmer, Lilly Lulay, Trevor Paglen, and Penelope Umbrico. They have each graciously offered the gift of their time, shared their insights and ideas with me through enlightening video chats and email conversations, and provided their encouragement and enthusiasm for this exhibition's premise. Being able to connect with these brilliant artists helped me to stay focused and keep up my morale through the isolation and anxiety of COVID-19. I also appreciate their patience and flexibility, as we have had to negotiate many challenges brought on by the pandemic, not least of which has been the postponement of the exhibition as well as other obstacles of uncertainty. Further thanks are warranted to Ali Feser for contributing an original essay to this catalog, "The Photo Is the Metadata," in response to the exhibition's theme. Her research has enriched this publication and expanded my own thinking on the idea of "metadata."

Organizing any museum exhibition requires the cooperation and assistance of many people outside of the institution. I am indebted to all of the following for their crucial help with logistics and liaising with artists: Silvia Bonsiepe at KLEMM'S; Allison Card, John Michael Morein, and Margaret Zwilling at Metro Pictures; Nicole Hughes of the Algorithmic Justice League; Ben Kuckei and Hannes Kuckei at Galerie Kuckei + Kuckei; Inés Lombardi at Galerie Georg Kargl; Aliza Morell and Steven Sacks at bitforms gallery; Andrew Rafacz; and Milan Simas at Antimodular Research. Deep thanks also go to Dr. Ena Heller, Bruce A. Beal, Director of the Cornell Fine Arts Museum at Rollins College in Winter Park, Florida, for lending works by Trevor Paglen for this exhibition, and to Dr. Gisela Carbonell and Austin Reeves at that institution for all of their kind assistance with the loan. My heartfelt thanks to Neil and Gianna Rendina-Gobioff for their loan of artwork by Mohsen Azar and for their zealous support for the arts in this region.

I have been supported by my colleagues at The Ringling through the entirety of the curation of this exhibition and the production of this catalog, and for that I am profoundly grateful. I am inspired by and honored to work with this talented group of individuals who continued to devote themselves to the museum's mission and purpose, even through the most challenging hardships of the pandemic. I am appreciative for Executive Director Steven High's unflagging support for the vision of curators and for innovative contemporary art and programming that defies genre and breaks boundaries. It is a privilege to be a part of a supportive curatorial department that fosters a creative and intellectually critical environment, all due to the inspiring work of my colleagues: Dr. David Berry, Dr. Sarah Cartwright, Dr. Elizabeth Doud, Marissa Hershon, Jennifer Lemmer Posey, Kyle Mancuso, Ola Wlusek, Dr. Rhiannon Paget, and Sonja Shea. Regarding this catalog, special thanks are due to Ola and Kyle for critical feedback on portions of the manuscript. Head of Education Laura Steefel-Moore has provided insight and advice on the exhibition's development, as well as related programming for our community.

Within the museum, there are a number of key individuals without whose professionalism and tireless attention to detail this exhibition would not be possible. These are Jemma Fagler, performance and curatorial program associate, and Ellie Bloom and Heidi Taylor, associate

registrars, who have attended to all of the necessary administrative and organizational logistics crucial in pulling off an exhibition with an international group of artists. My thanks to our Senior Preparator Keith Crowley and Museum Preparator William Rollins for their skill and artistry in handling objects and creating transformative spaces in our galleries, and to conservators Barbara Ramsay and Emily Brown for their perspicacity and care for artworks. My gratitude goes to Libby Bennett and Katie Booth for their adept design of museum graphics and didactics, such an integral part of a successful exhibition experience. Our development team—Erica Bacon, John Melleky, Mark Terman, and Michelle Young—have worked resolutely to make this, and so many other museum projects, possible.

It has also been a pleasure to work with the team at Scala Arts Publishers. My gratitude goes to Jennifer Norman and Claire Young for their careful guidance through the catalog's production and to Magda Nakassis for her patience and copyediting wizardry. I am grateful for the work of Antonio Alcalá and Marti Davila at Studio A. Antonio's beautiful catalog designs and cohesive layout present all of the artworks to their best advantage while creating a unique vision for the show's concepts. Thanks to all of them for keeping the project on track and on time.

Our nascent photography and media arts department would not exist if not for the enthusiasm and generosity of its benefactors. Among the most important are Warren J. Coville and the late Margot Coville. The Covilles' gifts of over two thousand photographs beginning in 2012, representing a lifelong love of photography and decades of collecting, provided the core of the museum's holdings in photography and a resource for our continuing exhibition programming. The prodigious support from Stanton B. and Nancy W. Kaplan enables us to build upon this foundation and expand our possibilities to inspire and educate through exhibiting, collecting, and researching photography and media arts. Personally, I would like to thank both Warren Coville and Stan Kaplan for sharing with me their passion as collectors, their wisdom as connoisseurs, and their hospitality and encouragement over the years.

Metadata: Rethinking Photography in the 21st Century is supported in part by a grant from the National Endowment for the Arts and by the State of Florida, Department of State, Division of Arts and Culture and the Florida Council on Arts and Culture. Additional support is paid for in part by Sarasota County Tourist Development Tax Revenues.

This exhibition is a part of the Stanton B. and Nancy W. Kaplan Photography and Media Arts Program at The Ringling.

Christopher Jones
Stanton B. and Nancy W. Kaplan Curator of Photography and Media Arts
The John and Mable Ringling Museum of Art

The Exhibition's Metadata

CHRISTOPHER JONES

The concept for this exhibition and catalog was sparked by a conversation with artist Jason Lazarus during his installation of *Recordings #5 (Isabel)*, part of the exhibition *Skyway: A Contemporary Collaboration* in 2017. For each of the *Recordings* installations, Lazarus created a small archive of photographs selected from his collection of found snapshots and vernacular photos obtained from thrift stores and flea markets. It is an archival methodology shared by many contemporary artists engaging with photographic discourse, but Lazarus radically changed the rules of our encounter as spectators: he arranged the photographs on the wall with the images turned away from us. It was a gesture that frustrated viewers' expectations, tantalizing our desire to see, but quickly we noticed the subtle yet rich visual artifacts on the backs of the photographs. There was the residue of glue and fragments of tape, reminding us that, before they were cast off into the sea of discarded things, these photos were once tipped into albums or taped onto bedroom mirrors, part of personal and familial archives that articulate identity and bear memory. One could also see the mechanical artifacts that index the production and life of the photographs as objects; these include the stamps of photographic paper manufacturers, the time and date stamps of the automatic printing machines of photofinishers, the mechanical imprints resulting from the fabrication of Polaroids, or even the splotches of foxing that mark the passage of time. Finally, one found handwritten inscriptions, in various forms of cursive or print, notating a date, place, or the name of a person, linguistic elements that anchored the unseen images within their previous archives and that now prodded our powers of imagination. Lazarus referred to all of these rich visual artifacts as "metadata," an idiosyncratic use of the term that spurred me to reflect on the broader condition of photography, past and present.

Using the concept of metadata to describe the marks and inscriptions on old photographs strikes us, initially, as anachronistic. The term in its broadest sense simply means "data about data," but it takes on specificity within various disciplines and applications.[1] We typically think of metadata in relation to the work of archivists and librarians, those

responsible for managing information architecture. In the digital era, we have understood metadata as the unseen text written into websites that makes them visible to search engine algorithms. With regard to images within a digital ecology, we also use the term in relation to Exif data, the time and location that our phone or digital camera encodes into the picture file. In this technical, contemporary sense relating to digital images, Daniel Rubinstein and Katrina Sluis have identified two types of metadata:

Descriptive metadata which is generated mechanically during image creation or added later to the file (containing details such as date, location, camera make, owner, keywords) and is carried within the file; the second type is collected as a valuable by-product of interaction with the image (tags, comments, ratings, number of viewings) and is stored independently of the image.[2]

Expanding our concept of metadata from the present into the past, we can see how well the concept of the digital images' metadata can also describe the artifacts and inscriptions found on the backs of snapshots and analog photographs. Both contain automated or mechanical marks that record the logic of their production; the time and date stamps that facilitate their place within an archive of images; and the linguistic descriptions, now called tags or hashtags in the digital environment, which anchor potential meanings or readings of the image. What we find, in approaching the photographic image, whether analog or digital, is that it is a vehicle for a register of information beyond, and even ambivalent to, the representational content on its surface, be that a screen or a piece of paper. It is an object continually accruing data and meanings as it circulates and interacts with users, potentially recording those encounters as another layer of metadata. Finally, a defining quality of metadata is that it is often unseen to us when viewing the image. This type of metadata is the logic of the filing cabinet, or the code of the algorithm.

As photo historian Estelle Blaschke has explained, photography has always served as a carrier of data as well as a carrier of images, a crucial element in the history of bringing things into a certain order.[3] In this reading of the medium's history, a desire to infuse images with more data arguably culminated in the development of digital scanning and imaging technology.[4] Photographs, usually accumulating in mass, made meaning within an ordering structure, and were tagged with handwritten inscriptions or labels. We can think of these organizing structures and labels as metadata; as archivist Anne Gilliland reminds us, as a construct, "metadata has been around for as long as humans have been organizing information," even if the term has entered our vocabulary only recently.[5] The first great era of photography for and by the masses—with the introduction of the Kodak and Brownie cameras in 1888 and 1900, respectively—corresponds to the time in which "the archive became the dominant institutional basis for photographic meaning."[6] Photographic archives became central to "a bewildering range of empirical disciplines, ranging from art history to military intelligence," as well as the famous Bertillon system for using photography to identify criminals through a standardized mug shot.[7] Rethinking photography's past from the present, art historian John Tagg has described the medium's

role as an archival apparatus as a "kind of computer—in which the camera, with its less than efficient chemical coding system, is hooked up to…the upright file."[8] Key to all of these archival systems is the metadata, the information about each object, its label, structuring architecture, and classification within a taxonomy, which gives the photograph its relational meaning. The act of classifying and ordering itself is a political act of power, as we know from Michel Foucault, and part of a broader archival logic not restricted to libraries, but upon which disciplines base their foundational discourses, produce their truths, and construct their bodies of knowledge.[9]

Therefore, metadata is perhaps also a way to approach the idea of photography itself, not as a specific medium but as a system or an apparatus that organizes. In light of its reconfigurations over the past thirty years—from an analog, chemical material, to a digitally encoded computer file, to a network of images captured by phones and automated cameras—there is a need to rethink and redefine the history and continuity of the photograph. As photography historian Geoffrey Batchen reminded us in 1999, as many were lamenting the death of photography in the midst of its digital turn, "photography has never been one technology" but rather nearly two centuries of "numerous, competing technological innovation and obsolescence," under the rubric of a continuing medium.[10] We are reminded of the archaic daguerreotype, calotype, ambrotype, and various other photographic formats that were made obsolete long before digital technology displaced the gelatin silver print. These forms are the historic embodiments of the idea of photography. What this medium actually comprises, Batchen argues, is a "persistent economy of photographic desires and concepts [such as] nature, knowledge, representation, time, space, observing subject, and observed object," which are linked by "the desire to…orchestrate a particular set of relationships between these concepts."[11] However, in the twenty-first century, when growing numbers of images are created by machines, to be "seen" and acted upon by other machines, the concepts of "representation" and "observing subject" (in Batchen's triangulation of the medium) are increasingly displaced. We need to refine even further what photography means for us.

More recently, media theorist and artist Joanna Zylinska has proposed an updated ontology for photography at a moment when image-based media saturate our "biological and social lives." From her broader theory of "photomediations," she defines photography as "an active practice of making cuts in the flow of imagistic data, of stabilizing data as images and objects," wherein the "cut operates on a number of levels: perceptive, material, technical, and conceptual."[12] These cuts are made by human and nonhuman agents, such as CCTV cameras mounted on Google Street View cars and satellites, all participating in the "wider process of imaging the world." As such, photography does not merely represent life, but also "participates in its active cutting and shaping."[13] These two expanded notions of photography, as conceptualized by Batchen and Zylinska, have informed my approach to curating this exhibition, connecting the metadata of photography's past to its present in an effort to trace, to use Zylinska's words, the "technological, biological, cultural, social and political" data that produce photographic objects.[14] The artists selected for this exhibition reflect a myriad of diverse practices and perspectives; some make use

of the camera to create images, while others engage with algorithms, artificial intelligence, appropriated images, mixed media, or other materials at the periphery of photographic production. Yet, their common ground is that these artists work to make this data, or metadata, that produces photographic objects visible for us. This is crucial because the unseen structures that organize images and give them meaning also organize what we see and define who we are.

RECONNECTING METADATA

Several of the artists in this exhibition explore the genealogy of photographic expressions, analog and digital, and map interpenetrations between the two. Through diverse methodologies, these artists work to reveal the unseen information of photographic technologies: the origin stories and desires organized within the industrial capitalist economy of the twentieth century. One of these projects is a new collaborative, site-specific installation by artist **Jason Lazarus**, whose artwork *Recordings* was discussed at the opening of this introduction, and anthropologist **Ali Feser**. Titled ***Man and God*** (2022), the work is an "anthropological inquiry and embodied estrangement," as the two describe it, into the Eastman Kodak Company. Underpinning the project is an account of the creation of Kodachrome, the first stable color film technology, by musicians Leopold Mannes and Leopold Godowsky Jr. in 1935. However, *Man and God* expands to excavate broader topics of race, labor, and the environmental impact of this monumental photochemical corporation, issues belied by the seductive surfaces of snapshots depicting family and leisure. Lazarus and Feser invite us to reconnect with this metadata of image production through archival materials, paraphernalia, sculpture, video, sound, and text—offering an expanded, embodied experience in the gallery space that pushes back against the "mass standardization" of the visual sensorium that the corporation attempted to effect.[15] They have also extended this project into social practice, offering a series of workshops that invite the public to re-create protest signs seen in historical photographs documenting demonstrations of Kodak. The first of these workshops, entitled *Reconnecting Metadata: Race, Labor, and the Corporate Body through the History of the Eastman Kodak Company*, was conducted online in March 2021 in conjunction with the University of Chicago. Participants may leave these signs to accumulate and become part of the installation. These methods provide a model for opening up the photograph to new possibilities of activation and connectivity.

 Mladen Bizumic's practice focuses on close examinations of photographic production with regard to its material condition and socioeconomic history. Obsolescence is a recurring theme of exploration in his work, as is the transformation from analog to digital photography and the mixing of the two. His installation ***MoMA's Baby*** (2019) offers a site for reflection on the origin of the digital image scanner, the beginning of machine vision. Spurred by the senescence of the malfunctioning scanner in his studio, the artist explored the invention of digital imaging by American computer engineer Russell Kirsch, who developed the first digital scanner while working at the National Bureau of Standards in 1957. Bizumic conducted interviews with his wife, art historian Joan Kirsch, who worked at the Museum of Modern Art in New York and contributed to her husband's work, though the

importance of their relationship has often been overlooked in histories of digital technology. Alongside images of the Kirsches and their son Walden, whose photograph was the first scanned and digitized image, Bizumic intersperses photographs of his studio, where the phone interviews were conducted, with photographs from his *ALBUM* series. In relationship to one another, these images operate to provide a layer of self-reflective metadata surrounding the creation of the installation. In the *ALBUM* photographs, Bizumic pushes the scanner to its design limits, scanning glass and causing uncontrolled light from the apparatus to refract, creating something like abstract photograms that also bear traces of the flatbed surface. The technique is reminiscent of the photograms of Hungarian avant-garde artist László Moholy-Nagy (1895–1946), who urged artists to interrogate the apparatuses of reproduction through experimentation in order to make new types of artworks and meanings.[16]

METADATA ORGANIZES NEW INTERFACES

One of the paradoxes of our networked photographic culture is that although the image abounds, its efficacy and value as an individual unit seems to have waned. There are images that "trend" or become memes, circulating and repeating more widely for a time, but soon enough they slip out of our news feeds. As scholar Martin Lister noted, "We anticipate that behind an image we have alighted on there is another waiting or there is one, seen earlier to return to. Rather than absorbing us in a singular manner each image seems to nudge us toward another."[17] Likewise, artist and writer Joan Fontcuberta reflected that "images do not matter by themselves but to the extent in which they are interconnected within certain contexts."[18] Although it is difficult now to imagine a time without the perpetual flow of images to scroll through, our current image regime began only ten or fifteen years ago, with the proliferation of camera phones and the new formulations of "Web 2.0," which facilitated digital image circulation and consumption. Media theorist Lev Manovich was among the first to foresee the significance of a "metadata paradigm" in 2002, in the early stages of this proliferation of digital images. He surmised that the "cultural unit is no longer a single image," but an image database.[19] Providing organizational logic to this vastness of images would open up a "new paradigm to 'interface reality' and the human experience" by focusing on "new ways to describe, organize, and access" visual material.[20] Machine-readable metadata, an automation of the archival system, would enable these new kinds of interfaces. Web 2.0, the revamped incarnation of the internet, born from the ashes of the dot-com crash of 2001, was predicated on user-generated content, social networking, and the concept of the "platform" as the point of interactivity.[21] Ubiquitous photography became a defining quality of life, typically experienced as an inexhaustible stream of images. In 2014 it was estimated that some 1.8 billion pictures were uploaded and shared every day.[22] By 2015 we were taking one trillion pictures annually, 80 percent of them with our smartphones or tablets, and the numbers have grown exponentially since.[23]

The work of **Penelope Umbrico** responds to this surplus of images we create, share, and store online. Using search engines to sift through our collective archive, organized and classified by its descriptive metadata, Umbrico seeks out social phenomena as an

anthropologist might, revealing our rituals and practices involving photography. Several of her projects have utilized Flickr, the first major online community organized around hosting and sharing images, as a resource for her appropriation. In her series *Sunset Portraits from Sunset Pictures on Flickr* (2010 to present), the viewer is overwhelmed by a mass of photographs in the gallery space organized into a grid, each image depicting figures photographed against the setting sun. In every photograph, however, the camera's exposure algorithm has calibrated for the bright sun, leaving the subjects anonymized in silhouette. By way of this technological glitch, Umbrico reveals a condition of the photographic apparatus: that as we perform our identity through our engagement with it, we are also captured in a process of de-subjectification.[24] We are vanishing as we insist on our presence in a given moment. Conversely, in her *TVs from Craigslist* (2008 to present), Umbrico finds a more candidly expressed individuality through unintentional portraits. In Craigslist advertisements, sellers hoping to dispose of a television have photographed the device, accidentally capturing their reflection in the TV screen. If the object of exchange is the television set, then we may find the subjectivity of the seller as an apparition of metadata.

Whereas Penelope Umbrico stages images en masse to re-create the volume of images we experience online, **Mohsen Azar** considers individual images of politically charged trauma—ones that we consume, meditated by online platforms. In *As of Now…*, Azar works with a series of such images, including the 2015 photograph of three-year-old refugee Alan Kurdi and the image of Eric Garner's death at the hands of police in 2014. These types of images remind us of the writings of Susan Sontag, who debated the ethics of the photography of suffering throughout her career and ultimately concluded that traumatic images invite us to "pay attention, to reflect," and to ask: "Who caused what the picture shows? Who is responsible?"[25] Although these images activate our sense of responsibility to one another, Azar reflects on their life spans. The intensity of hashtagging and sharing when these images are new is recorded into their metadata, read by algorithms, and thus they are brought to the tops of our news feeds; however they soon lose their ability to capture our attention within a sea of competing pictures. Azar insists that we continue to attend to these images, uploading and downloading them to Instagram every day. This reparative gesture also exploits the compression algorithm on the platform that slowly causes the image to degrade over time, until it is lost in a swirl of abstract pixels. Azar creates light box displays documenting the image decay at intervals, offering abstract forms of commemoration, but also uncovering the reality that images have an unstable, processual nature in the digital environment.

METADATA ENGENDERS A NEW TYPE OF IMAGE

Metadata has enabled a new kind of image. Rubinstein and Sluis described it as a "networked image" because of its orientation toward transmission through online platforms and an experience via screens.[26] Sites like Flickr and now Instagram have popularized user interaction with images through commenting, liking, or tagging (later hashtagging), allowing users to annotate and categorize images, creating meaningful linkages and hierarchies among them. These tags and comments are readable by search algorithms and make

images accessible and retrievable, uniting platforms across the internet into a single global database. Technology has enabled what Vilém Flusser imagined in 1989: a new form of networked image with decentralized authorship, which has disrupted the sender–receiver model of communication. Anyone can tag or comment on images—edit, manipulate, or even add text to create image macros or memes. Users become authors. However, a critical byproduct of the condition of the image, networked through the logic of metadata, is that its meaning is always in flux, its coherence unstable. As Michelle Henning described it, our experience of the image on-screen is merely a "temporary stopping point in a process by which [it] reproduces itself, but also changes as it accumulates metadata…the image itself is a multitude, a growing and changing mass of data."[27] According to Rubinstein and Sluis, "metadata opens the image to a wide range of influences which depend not on the content of the image, but on the decisions (wise or unwise) made by users."[28]

Under the logic of metadata, the representational function of the image, at least in its pictorial or traditionally photographic sense, has been displaced. The image has become a site of processes. The computational operations that occur unseen to us have, in many ways, more value, more meaning than the content of the image itself. Ingrid Hoelzl and Rémi Marie have used the term "softimage" to theorize on the new fusion of the image with software. In this configuration, the image no longer "functions as a (political and iconic) representation, but plays a vital role in synchronic data-to-data relationships [and is not] a stable representation of the world, but a programmable view of a database that is updated in real-time."[29] The image becomes a calculable surface in which "the photograph is valued not as a singular object, but as a resource to be deployed in endless and varied successive contexts."[30]

As the representational and signifying value of images has arguably declined, their instrumental function has increased exponentially in the era of metadata. This evolution of the image also reflects the fact that the creators and users of images, the participants sharing the networked image, are not all human. Computer algorithms translate the pixels of a digital image into the code of mathematical relationships for comparison with other images traveling the network. These programs read the metadata embedded in or associated with image files in order to categorize them, retrieve them (for search queries), or prioritize them (to appear at the tops of our social media feeds). Metadata is also a mediator between humans and computers in our ongoing project to create meanings for images within ever-changing taxonomies.

The practice of **Viktoria Binschtok** involves collaborating with automated systems that produce such fluctuating taxonomies online. In her series *World of Details* (2011–12), she appropriates images of New York City mined from Google Street View, the online panorama produced by the company's fleet of ever-roving cars with roof-mounted cameras.

ABOVE
Jason Lazarus, *Recordings #5 (Isabel)* (detail), 2017. Installation view in *Skyway: A Contemporary Collaboration*, The John and Mabel Ringling Museum of Art, 2016. Image courtesy of the artist

Binschtok then visits the exact location of these scenes in person to photograph details at the site. Bringing these new sets of images into the gallery creates a point of intersection between automatism and intentionality, online and physical space. In later works such as *Cluster* and her new *Networked Images*, Binschtok works directly with image search algorithms to produce installations of image groupings. She submits her original photography to image search engines that return results using mathematical values of the image, such as color or shape. The search results return images that have formal similarities but are otherwise random, which Binschtok then re-creates in new photographs. When she combines these, we see a representation of machine thinking that reflects a condition of photography in the era of metadata. As Rubinstein and Sluis noted, photography has become an "unstable surface that produces meaning not through indexicality or representation, but through the aggregation and topologies of data."[31]

Mixed-media artist **Lilly Lulay** explores our relationship with images as interfaced through our most intimate of devices: the smartphone, a technology that mediates so much of our individual and collective experience of the world. Although our experience of images on our screens feels direct and transparent, in her series *Lesson I: The Algorithmic Gaze* Lulay works to materialize the unseen structural logic that orchestrates that encounter. In these photographic works, she creates an analog version of an algorithm programmed to "see" images, using stencils placed over appropriated found photographs from the 1960s and 1970s. These overlays highlight certain aspects of the image and obscure others, mimicking the reductive forms of algorithmic logic. Lulay handwrites "metadata" onto the photographs' surfaces, reminding us that these human archival activities have become automated. The work is playful, but it provokes serious questions about the formulas written into programs created to organize what we do and do not see. Another related body of work, *Our Writing Tools Take Part in the Forming of Our Thoughts*, begun in 2017, similarly explores the smartphone as an apparatus that shapes our behavior. The title of the series is a quote attributed to Friedrich Nietzsche, reflecting on how the character of his writing changed after he began using a typewriter. Lulay's experience of mentoring an older friend in the use of her first smartphone made her more keenly aware of the visual metalanguage of icons and symbols that we use to navigate images online. This interface re-territorializes our encounters with images and guides us to a delimited set of social interactions—"like," "share," or "delete," for example. In this series of prints, Lulay has superimposed icons from apps into a network of patterns that she then laser cuts out of paper, leaving behind a labyrinthine circuit that cuts through the images. Just as the images are see-through, the artist warns that we are transparent as well: "As soon as we share, manipulate or archive our private photos, smartphone app companies take our location, interests and habits and add it to their data pools."[32]

METADATA IS POWER

These data pools or data centers are the foundation for what Matteo Pasquinelli describes as our "Metadata Society," a techno-political form that arose in the late 1990s with the advent of data collection centers.[33] In our Metadata Society, compiling vast amounts of

information about every facet of life—from the climate to stock markets, our spending patterns, and social networks—into data sets has become the "primary source of cognitive capital and political power."[34] Metadata in this sense is the meta-analysis of data in order to chart trends and make forecasts, thus rendering the enormousness of raw data into something meaningful that can be monetized. We as individuals also constantly generate valuable metadata through our behavior as we interact with networked technology, though we are often unconscious of its meaning. For example, researchers have found that they are able to accurately predict a subject's personality based not on the online content they share about their beliefs or politics, but by how willingly and how frequently they share.[35] Shoshona Zuboff has described the accumulation of this type of information as a new form of surveillance capitalism that "claims human experience as free raw material for translation into behavioral data."[36] The optimal situation for accumulating this type of metadata from us, according to Zuboff, is when we are at leisure, consuming images online, for example.

The goal of harvesting this behavioral surplus, through seemingly innocuous interactions online or with networked devices, is not just the accumulation of knowledge, but its deployment to "instrumentarian" uses, to shape our behavior toward profitable outcomes.[37] We have also learned, by way of leaks from Edward Snowden in 2013, of National Security Agency (NSA) programs such as PRISM, which conduct clandestine global surveillance as part of counterterrorism efforts in the wake of 9/11. Mimicking the actions of the "big data" tech companies, the NSA gathers enormous amounts of communications metadata. The notion that such material is innocuous because it does not directly eavesdrop on the content of conversations was undermined by General Michael Hayden, former director of the CIA and NSA, who bluntly acknowledged, "We kill people based on metadata." Here he was referring to the US military's signature drone strikes on battlefields around the world, part of its war on terror that targets subjects whose metadata signatures correlate to militant activity.[38]

In our increasingly automated society, one structured by the logic of metadata and algorithms, the majority of images are being created by machines, for other machines. German filmmaker and artist Harun Farocki explored these types of images in his *Eye/Machine* cycle of video works in the early 2000s, coining the term "operative images" to describe them.[39] In his work, Farocki explored the implications of automated imaging and the use of cameras to track targets and guide warheads during the 1991 Gulf War. These types of images were not part of a humanist-derived notion of a picture, but were part of an immediate process or operation. They did not represent objects, but tracked them in real time. These images, created via an automated camera and immediately interpreted by computer vision software, were in a sense invisible, as they were never intended to be seen by human eyes. Although we have redistributed vision outside of the human body, Farocki, by way of Paul Virilio, warns us that these images are "aimed at us."[40]

This "Metadata Society" of control is predicated on asymmetries in knowledge and surveillance systems designed to be unknowable and invisible to us. **Trevor Paglen** has been working to make visible these hidden circuits of power, be they the apparatus of

the surveillance state or the logic of AI implementing image interpretation as a means of automation. A series of his earlier works sought to map out the geography of the military intelligence surveillance network by photographing its "black sites" and charting the orbits of spy satellites, all a part of the space of state secrecy.[41] In the wake of the Snowden revelations, Paglen has come to rethink photographic images not as representational "windows on to a scene" but as "data and metadata surfaces to be parsed" in a broader data-scape.[42] A key aspect of this new visual regime is that the vast majority of images are made for and by machines without ever being seen by a human eye.[43] In his recent work, Paglen interrogates this automation of vision and the programming of convolutional neural networks, the kind of AI trained to interpret and act upon images. In *Machine Readable Hito*, we see the results of facial recognition algorithms struggling to "read" the artist's gender or emotional expressions. It is a satirical exposure of the machine's shortcomings, but should also concern us as these systems become evermore entwined in our daily life. Through his recent body of work exploring machine vision, such as the *Eigenface* and *Adversarially Evolved Hallucination* series, Paglen sets out to teach us to see like machines, creating pictures by cutting into the flow of invisible images so that we may better understand the logic of these systems. Although it is tempting to attribute the nightmarish scenes that Paglen coaxes out of the AI as a form of machine unconscious, he reminds us that these neural networks are "only able to relate images they ingest to images they've been trained on. And their training sets reveal the historical, geographical, racial, and socio-economic positions" of their human trainers.[44]

A poet of code and researcher at the Massachusetts Institute of Technology, **Joy Buolamwini** works to expose biases coded into algorithms and in the metadata of image sets used to train AI. She founded the **Algorithmic Justice League** in order to combine art, research, policy guidance, and media advocacy toward equity and accountability in the use of AI systems. Through her firsthand experiences as a computer scientist working with generic facial recognition software, Buolamwini found that because of her dark skin the algorithms could not detect her face unless she was wearing a white mask.[45] She uncovered similar widespread biases in AI services from companies such as Microsoft, IBM, and Amazon.[46] These biases built into AI systems are the result of image training sets that do not include people of color, but also reflect the conscious and unconscious prejudices of the people who design and program the systems, a phenomenon Buolamwini refers to as the "coded gaze."[47] Her spoken word video work, *AI, Ain't I a Woman?* (2018), demonstrates the misgendering and misidentification of famous Black women such as Michelle Obama, Sojourner Truth, and Ida B. Wells by face-reading AI while the poet asks, "Can machines ever see my queens as I view them? Can machines ever see our grandmothers as we knew them?" Whereas Paglen's *Machine Readable Hito* exposes the absurdity of machine vision, the mis-recognition of Black women in Buolamwini's work feels like a form of violence as she reveals the embeddedness of institutional racism in the technology itself.

Rafael Lozano-Hemmer also engages with facial recognition algorithms in his work *Level of Confidence* (2015), but he works against the apparatus of surveillance and reconfigures the technology in order to create an experience of remembrance and commiseration.

Lozano-Hemmer created a data set with portraits of the forty-three students from the Ayotzinapa Rural Teachers' College in Iguala, Mexico, who were taken into custody by police on September 26, 2014, and never returned home. A camera, connected to algorithms trained to identify the students' faces, continues to search for the missing, scanning the faces of participants who stand before a mirrorlike screen. After processing, the screen presents an image of the student that the participant most closely represents, along with metadata such as the level of confidence percentage, creating a moment of intimacy between the participant and the disappeared. Lozano-Hemmer's work often derives from technologies he calls "both violent and seductive." But removed from their instrumental uses to surveil and control, they open up to productive new opportunities.[48] He offers the work's code as an open-source tool for programmers to use and repurpose in other settings, reversing the flow of a technology typically used to accumulate and store information as a means of control.

The work of Paglen, Buolamwini, and Lozano-Hemmer remind us that the "Metadata Society" of surveillance and control, of which Zuboff and Pasquinelli warn us, is not yet a foregone conclusion. These artists have made palpable the failures and biases of machine vision, or shown how it can be redeployed for reparative, rather than instrumentalizing, purposes. All of the artists in this exhibition have provided new ways to visualize hidden processes, materialize the unseen forces that shape the production and consumption of images, and conceptualize the metadata of the photographic image. Opening up metadata grants us access to a new position from which to rethink the photographic image from the present, and reflect on how we have structured it, as it has structured us.

The Photo Is the Metadata

ALI FESER WITH JASON LAZARUS

Man and God weren't scientists by training. They were professional musicians (piano, violin) and amateur chemists (amateur, from *amour*, one who loves or has a taste for anything).[1] They started developing the process that would become Kodachrome film in 1917, back when they were still in high school, still Leopold and Leopold, Mannes and Godowsky.

They had gone down to Forty-Fourth Street to see *Our Navy*, an educational film shot at the Naval Academy in Annapolis. Advertisements had promised that the film would be

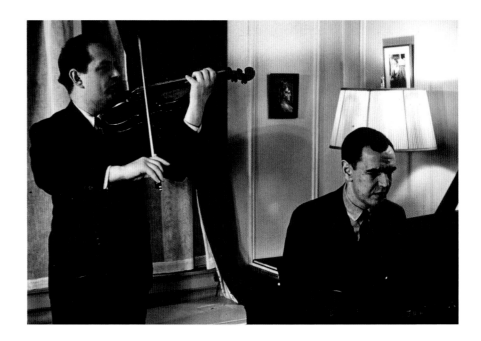

"projected in natural colors,"[2] but to Man and God, the spectrum on the screen "struck…as unreal": too "orange-red," too "blue-green."[3] With the audacity of adolescence, they swore they could do better. They began to experiment, with their parents' second bathrooms serving as laboratory and darkroom. They kept in touch while in college on opposite coasts and mailed reports across the Atlantic while Mannes toured Italy on a Guggenheim Fellowship. Once both back in New York City, they graduated from their parents' apartments to an old dentist's office and finally a suite at the Almanac Hotel, where bellhops filled in for lab assistants.[4]

At first, Man and God simply aimed to improve the additive color[5] system used to make *Our Navy*. But disappointed with their initial results, Man and God began to experiment with "subtractive color," first hypothesized by German chemist Rudolf Fischer in 1912. The subtractive system aimed to produce color in the film itself, through chemical rather than optical means. This was still very much a *theory* in the 1920s, as the developing process for subtractive film required the use of special chemical couplers that did not yet exist. But Mannes had "a knack for running into people,"[6] and he managed to broker an introduction to Dr. Mees, the director of research and development at Eastman Kodak. Mees was impressed enough to offer the boys research materials in exchange for periodic updates on their progress.

Mees had promised Man and God salaries of $7,500, a $30,000 bonus to be split between them, and plenty of time for music. But their piano and violin quickly gathered dust, as Man and God realized that there was an urgency to their hiring. It was the Depression. Film was a luxury, not a necessity, and corporate sales were down. Color film was supposed to be a way to get consumers dreaming again, and if Man and God didn't show results quickly, their positions risked being eliminated in budget cuts.

Mees's chemists managed to invent the chemical coupler they needed, but it was up to Man and God to make the developing process manageable. They needed to simplify the process so that technicians at Kodak plants around the world could replicate their procedures. This meant that Man and God needed to speed up the entire developing process, while simultaneously slowing down the individual chemical reactions that create color in the emulsion, bring the image to the surface, and "fix" it in place.

At first, the chemical reactions occurred in intervals as small as a second and a half. The process was so sensitive that the slightest variations in time would spoil the image. A stopwatch wasn't accurate enough, and besides, even the green dial of a radium wristwatch would excite the molecules in the emulsion and cause them to react. Color film had to be developed in complete darkness.

Instead of a watch, Man and God kept time with breath.

They whistled while they worked, dwarfs in a jewel mine, wringing color from coal tar.[7] They timed their procedures to the final movement of Brahms's Symphony in C Minor.[8]

It's cinematic music, verging wordlessly on narrative. It could be the soundtrack to a Technicolor epic—strings heave and timpani charges. When they break into sonata, it's

ABOVE
Where light strikes the surface of the film, the silver halide crystals dissociate. Electrons shoot off the bromide salts. Loose and cruising through the emulsion, they gather at aberrations in the gelatin and, gathering a positive charge, pull in the silver, now gone ionic. Attraction, repulsion, silver to electron, electron from bromide. The molecules rearrange in the pattern of the impact of light. From "Silver developing through an electron microscope," 1945, Box 199, Folder 2, Kodak Historical Collection #003, University of Rochester. Image courtesy of Kodak. Color added by Feser and Lazarus

ABOVE
This photograph was made by Hymen Meisel (1898–1985), a machinist at Kodak's Camera Works factory, a serious amateur, and a member of the Kodak Camera Club. Image provided by and courtesy of the Visual Studies Workshop, Rochester, NY. Color added by Feser and Lazarus

like a mountain sunrise at the start of a third act, the hero rising for his glorious denouement.

Music organized the temporality of the chemical reactions, and Man and God reorganized our senses. They transposed the crests and flourishes of Brahms's Romanticism into the fantasy palette of Kodak film.

Man and God would have played the parts of flute and oboe in duet, as they skirted each other in the dark, trays of developer and fix sloshing to a tempo of two beats per second.

This is the secret rhythm of industrial production, its time signature in every photograph.

Kodachrome began with pine trees and cotton. Workers at Eastman Chemical in Tennessee bleached, purified, and combined plant matter with acetic acid to make cellulose acetate. They precipitated the cellulose acetate into small, white pellets and shipped them to Rochester in railcars. Workers at Kodak Park dissolved the pellets in a solvent called methylene chloride to render the cellulose acetate into the golden, honey-like substance that Kodak called dope. The dope would be piped onto the surface of a giant, steel casting wheel. As the wheel turned, the solvent would evaporate, liquid into air, the dope dried to film base; and emulsions—the photosensitive part of film that reacts to light and forms an image—were sprayed on the surface of film.

Early black-and-white film needed only one layer of silver and salt suspended in gelatin. Man and God's color film needed three, each sensitized to a different part of the spectrum. The emulsions were applied in sequence as the film base moved along machinery that measured a mile long. Later on, when the film is exposed to light through the lens of a camera, a latent image is recorded on each layer of emulsion.

Kodachrome film had to be developed three times, once for each layer. In addition to the usual photo developer which renders visible the latent image, Kodachrome developer contained couplers that, when added to the emulsion, reacted with the oxidation product of the developer to form a dye right there in the film in the appropriate layer. It's like a chemical factory within a chemical factory.

When white light is projected through the developed film, it is separated into three parts of the spectrum. The top layer absorbs blue light, the middle layer green light, the bottom layer red light. What we see on-screen is the remainder. The image relies on separation.

Before Kodachrome could be introduced to the market, it had to be tested. Scientists subjected the film to rapid changes in temperature and humidity to speed up chemical time and see how the emulsions would transform and decay over the span of a human lifetime. They tweaked the formulas to keep fugitive molecules from wandering among the layers of emulsion and changing the appearance of the image. Over time, the molecules want to move, but Kodak scientists estimated they could hold the structure of the image in place for two hundred years, the colors as punchy and bright as the day they were developed.

The staff at the research labs also took the new film home with them. They tested it in front yards in KodaVista (a working-class, company-built subdivision that bordered Kodak Park) and living rooms in Meadowbrook (a white-collar subdivision in the suburbs). Workers photographed their families, and they studied the resulting images to understand how emulsion reacted in actual use. They calibrated the dyes by comparing how the green grass and the pink skin tones of toddlers in photographs corresponded to the material existence of workers and their families.

This distribution of photographic materials to workers went beyond just product development. It also contributed to a collective identity among workers: for an annual fee of five dollars, they joined the Kodak Camera Club; they collected antique cameras; they submitted portfolios when applying for promotions. Even though labor was compartmentalized throughout the space of the factory, employees could grasp the sum of their labor in the shared practice of photography.

Photography was central to the world that Kodak created for its employees and their families. Founded in 1880, the company functioned like a total institution and a proxy for the welfare state. In order to win workers' loyalties and prevent them from unionizing, Kodak offered excellent benefits, good pay, and the tacit promise that workers' children could also find jobs at the company, a practice that reinforced the white homogeneity of its workforce. These measures generated a shared social reality for many workers, as social welfare programs and a paternalistic ideology of the "Kodak family" shaped their life experiences and aesthetic dispositions. Employees, in turn, applied these regimes of sensuous knowledge to the engineering of photographic technologies. They inscribed into photographic emulsions a chemical preference for white, middle-class life as the subject of the image. Through advertisements and other mass media, consumers learned to domesticate this vision of the American Dream. It became a fantasy for the "good life" and a normative template for how to see the world. Just as Man and God inscribed the Romantic swells of Brahms's symphony into the color image, Kodak's precise organization of labor and life is layered into every photograph.

Kodachrome motion picture film was patented and released to consumers in 1935. Kodachrome still film came out a year later. Advertisements celebrated the lifelike colors of the film and the longevity of the images it produced. An ad from 1937 warned consumers that their memories are only safe once preserved "in your snapshot record" where "time and change can't rob you of them." Another ad read: "These little pictures—almost as alive as the people they show—are the connecting links between yesterday and today... today and tomorrow."[9] According to the copy, Kodachrome had the capacity to freeze time.

But while laboratory tests suggest that Kodachrome slides should retain their vibrancy for two hundred years, they are still sensitive to their environment. They fade faster with more light; moths and molds have a taste for the gelatin coating; higher temperatures and tropical climates excite the molecules, inciting them to wander and react.

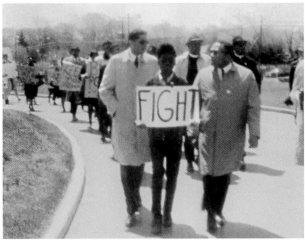

ABOVE

The racial and economic justice organization FIGHT—Freedom, Independence, God, Honor, Today—formed in Rochester in 1965 under the leadership of Minister Franklin Florence (right) and Saul Alinsky. At this particular protest, held at Kodak's annual shareholder meeting in 1967, FIGHT was campaigning for Kodak to commit to hiring more Black employees. From *Through Conflict to Negotiation*, directed by Bonnie Sherr Klein and Peter Pearson (Montreal: National Film Board of Canada, 1968), documentary film. Color added by Feser and Lazarus

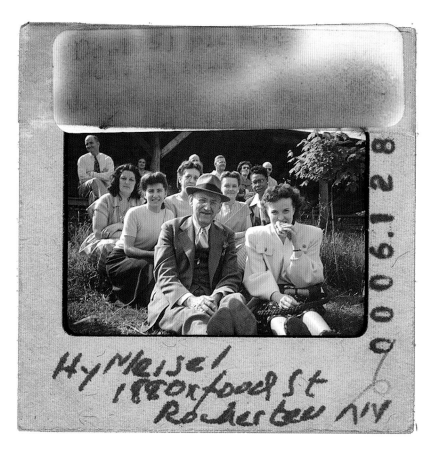

Another photograph by Hymen Meisel (1898–1985). Image provided by and courtesy of the Visual Studies Workshop, Rochester, NY

Photographs do change over time, even if on timescales that exceed our perception. Other film stocks age more quickly. Kodak's professional films from the 1970s yellowed within two decades; a typical, drugstore color print will fade within just one. Even black-and-white film changes. In an effect called silver mirroring, the image loses its crispness. Shapes bleed into each other and the edges become soft and dreamy.

Photographs can never be perfectly fixed because, as the advertisement says, they are almost alive. They are dynamic, chemical things. The molecules in the emulsion are propelled, and held in place, by the force of attraction to and repulsion from other substances. They are drawn through the surface of the film; they react and recombine. In doing so, they push against structure and transform the image. The atom has that "something in its breast," Karl Marx writes, "that can fight back and resist."[10]

Karl Marx worked out his theory of human agency through this capacity of matter to resist the structure imposed on it. His doctoral dissertation, "The Difference Between the Democritean and Epicurean Philosophy of Nature," compares two ancient Greek concepts of the atom. On the one hand, Democritus and the Stoics believed that form bears down on atoms with a gravitational force that locks substance into structure. In contrast, Epicurus believed atoms to have swerve. He thought that atoms were propelled by their attraction to and repulsion from other substances; it was the desires of the atoms that held structure together. These relations are reactive and contingent. This dynamism, Marx notes, creates the possibility for chance and change. If atoms can resist their form, then so can we. If matter can change, Marx writes, then "what is possible may also be otherwise, the opposite of what is possible is also possible."[11]

Kodak tried to "fix" social life, just as they had fixed the molecules in photographic emulsions. The company's corporate archives suggest that its labor policies were intended to prevent workers from unionizing, to cultivate their loyalty to the company, and to reproduce a certain brand of white, middle-class subjectivity.

This effort went well beyond the factory walls at Kodak Park. George Eastman, the company's founder, remade Rochester. He built parks for workers to frequent on their days off and negotiated the construction of local water and transportation

infrastructure. He funded music halls, hospitals, universities, and a global network of inexpensive dental clinics. He founded what would become the United Way in his billiard room, and he lobbied both the US Congress and the League of Nations to adapt the thirteen-month calendar he had imposed at his company for the sake of easier accounting. He was trying to fix the future.

Along with John D. Rockefeller, Eastman was also a primary benefactor of the American Eugenics Society (AES). AES was a national association for research and education on eugenics; it served as a sort of clearinghouse, distributing financial support to smaller scientific research projects as well as policy research regarding sterilization laws and immigration restrictions. Eastman's interest in eugenics is coterminous with his attempts to, as he is reported to have said, "make Rochester a place worth living in." Kodak, with Eastman at its helm, attempted to shape the life experiences of its employees, the lived environment of Rochester, and the racial future of the nation so as to stabilize social life, thus ensuring the reproduction of Kodak's mode of production.

Over time, though, scientists and executives learned that matter, especially human matter, tends to swerve from the structures imposed on it. Fugitive molecules wander through the layers of emulsion, degrading the image over time. In the 1960s—and chipping at the racial order of US industrial capitalism—Black Rochesterians would demand their inclusion in the workers' utopia that Kodak offered to its employees. In the 1980s, the industrial waste that Kodak thought was buried around its factories would bubble to the surface, inciting a public health crisis in KodaVista. At the same time, global transformations in patterns of capitalist production and accumulation would make Kodak's labor policies unsustainable. Since 1982, the company has reduced its workforce from over 62,000 employees to around 1,200, and Kodak eventually filed for Chapter 11 bankruptcy in 2012. The dream of mass industrial abundance[12] and middle-class flourishing[13] created by Kodak showed itself, in the longer run, to be exclusionary, toxic, and temporary. Its workers' utopia went the way of old photographs.

As we pass from the analog to the digital age, we are at an urgent moment to unearth the ideologies of industrial capitalism that continue to shape our visual conventions and visions of the "good life." The photograph is the metadata—every snapshot is an artifact of Kodak's organization of labor and social life. The wandering molecules of wet photography are physical links to this past and ciphers for comprehending[14] the long-lost ordinaries and moments of rupture concealed in the image regimes of the present.

Acknowledgments

This essay is based upon research supported by the National Science Foundation under Grant Number 1559245. Participants of the Mass Culture Workshop at the University of Chicago—Allyson Nadia Field, Salomé Aguilera Skvirsky, Cameron Hu, Jesse Malmed, and Christina Rosetti—all provided invaluable commentary on earlier drafts. Thank you to Christopher Jones for editorial feedback and his critical enthusiasm for Man and God. *And immense thanks to my collaborator Jason Lazarus for the gift of thinking together over the past decade about archives, images, and the world at large; his insistence on specificity;*

OVERLEAF
Lilly Lulay, *Am Muttertag 1976/On Mother's Day 1976* (detail), from *Lesson I: The Algorithmic Gaze,* 2020/21, scanned found photo, inkjet print on Hahnemühle Photo Rag Baryta, laser-cut wood plate, blackboard paint, and pen. Courtesy of the artist and Galerie Kuckei + Kuckei, Berlin. Photograph: Thomas Bruns

$$= \frac{2}{2} + 2$$

$$= \frac{1}{2} + 3 \times 10$$

$$= 3 \times 2$$

$$= 3 \times 4 + 2 \times 4$$

$$= x \%$$

Artist Interviews and Biographies

This catalog includes interviews conducted between October 2020 and February 2021 with all of the exhibition artists except for Joy Buolamwini, who was unavailable during this time. The illustrations within represent the work of these artists but are not meant as a precise record of the exhibition. Due to the logistics of working with an international group of artists during the uncertainties of the COVID-19 pandemic, the exact exhibition checklist was not yet finalized at the time of this catalog's publication.

Interview with Mohsen Azar

CHRISTOPHER JONES
November 30, 2020
Conducted via Zoom and email

CHRISTOPHER JONES: You were born in 1991 in the Islamic Republic of Iran, twelve years after the Iranian Revolution and just a few years after the Iran–Iraq War ended. You grew up and were educated in Iran. Are there any particular experiences that influenced you or inspired you to become an artist?

MOHSEN AZAR: It's true—I grew up in a society in the shadow of war. I felt this relationship, an awareness and empathy for the pain of others in my family and in the lives of those around me.

I have a memory from my childhood. My father suffered from the side effects of chemical bombs that he encountered as a soldier in the Iran–Iraq War during his mandatory military service. I remember leaving him lying in a hospital bed at home on my first day of school. All day long, I suffered from the thought that my father would not be alive when I got home. My teacher took a picture of each student at school that day. In the photograph was a seven-year-old boy. Yet every time I see this photo, I see the trauma of that day and the trauma that my father suffered. This is the power dynamic at play within a photograph and what I continue to explore within my work. Susan Sontag wrote in her book, *Regarding the Pain of Others*:

"We"—this "we" is everyone who has never experienced anything like what they went through—don't understand. We don't get it. We truly can't imagine what it was like. We can't imagine how dreadful, how terrifying war is; and how normal it becomes. Can't understand, can't imagine.[1]

One of the reasons I chose to be an artist was the capacity art holds for acts of creative resistance. One profound example of this capacity—which inspires me—is the story of a farmer named Darvish Khan Esfandiyarpour.

In 1963 the land reforms enacted by the Shah of Iran redefined ancient property lines in a wave of militant social restructuring. Furious, a farmer named Darvish Khan Esfandiyarpour sought to retain his land. But born mute and deaf, he needed to protest in a nonverbal manner. He stopped watering and taking care of his land, creating a garden of dead trees which he adorned with thick wires, chains, ropes, and stone fruit of various sizes. This Stone Garden, as he termed it, became completely undesirable to the Shah and the farmer's land was never seized by the regime.

He had created a silent argument against the atrocities carried out by the agencies of power and was successful in his persuasion!

I think of creative resistance as a material within my studio practice that I use in combination with different mediums and ideas.

CJ: What was the motivation behind the *As of Now* project? What led you to create this body of work?

MA: Once in a while, there is an image that makes it to the headlines and gathers lots

of empathy and/or attention. *As of Now* is meant to explore the life cycle of this digital image. Where does the image go or what happens to the image as our relationship to it changes? In this work, the materiality of the imagery changes. What happens to the once-present pain?

I myself experienced how documented atrocities can make waves in the psyche of a society and then evaporate as quickly as they rolled in. This is a representation of such an experience.

In this series, I have taken multiple depictions of trauma from mass media and given them each their own account on Instagram. I then upload and re-download the images thousands of times. Each cycle signifies a day that had passed since the image was captured....I inflict suffering upon the digital documents, slowly stripping them of their data. In this new context, these images are allowed the physical property of decomposition, which the viewer can witness in the account feed. The images suffer their own trauma as they are corrupted and broken down. This process makes clear their physical properties as the decomposition becomes more exaggerated and pronounced.

CJ: How did you choose the specific images for this project? What aspects unite them? Was there an image that was especially difficult to work with?
MA: *As of Now* consists of worldwide images of traumatic events, including the Malaysian Airlines crash of 2014 (shot down by Russian missiles) and the death of Eric Garner. There are two videos in the series: one is a thirty-second clip of the "falling man" from 9/11 media footage, and most recently the cell phone documentation of George Floyd's murder. There are also similar images from Iran and the Middle East.

All or most of the images in this series are of the moment of death....The other commonalities are that these images caused authentic public outcry, became political symbols, were used in multiple media sources, and then were overshadowed by the same system that created them.

For me, the most difficult image to work with was Alan Kurdi's photograph. His body on the beach symbolizes the tragedy that is affecting thousands of children in Syria. For me, as someone who has followed the story of Syria since its beginnings, seeing that photo was a raw depiction of how unimportant his life, and the lives of those like him, were to agencies of power.

CJ: When we create and share images online, we are typically unconscious of the technology that enables them or the infrastructures that support these social media platforms. The processual aspect of your work reveals some of the mechanics of Instagram—the compression algorithms, for instance. What does exposing this unseen or unconscious aspect of the digital image ecology help us to understand?
MA: In a way, this question speaks to the reason I make the work: to expose the system of looking at images of pain. In an image-proliferated culture, we spend so little time looking. And what we are glimpsing is rapidly changing. I turn social media upon itself, exposing the vulnerabilities of these digital images—showing how quickly they disintegrate as a means to expose the platform itself.

CJ: The fact that digital images—especially "lossy" formats like JPEGs— are susceptible to decay over time and through usage gives them an almost physical or material quality. How does this change or complicate our understanding of digital images?
MA: Exactly. I think it's that imperfection, the vulnerability, the degradation (and almost physical or material quality) that allows me to sit with the images and allow them to work on me. This labor of returning to the same image each day, uploading and downloading it thousands of times, is a way to honor the image: to stay with it. It is, in a way, a meditation.

CJ: The *As of Now* series exists across media and formats. There are Instagram accounts for each image, you made prints of particular moments in the process, and now you are producing these works as light boxes. Is there a format or form of presentation that you prefer viewers to experience?

MA: I have gone through this process with six different images so far. Besides the most recent one, *George Floyd As of Now*, I used Instagram simply as the digital platform by which I create them.

Digital media has been accepted in a very rapid, smooth, and easy way despite its huge and complicated effects on our lives. For that reason, I think using my small phone to produce them and showing them in large light boxes is the best way to present this series.

It becomes different in *George Floyd As of Now*, as I begin to use the digital platform as a way to record notes and expand the potential presentation of the work.

CJ: "Trauma," defined in a psychological sense, is an emotional response to a deeply negative event that one is unable to process, fully constitute, or move past. The imprint of this encounter keeps returning and repeating in other ways, even though the subject tries to repress it. You have discussed your work in relation to trauma. Could you elaborate on that?

MA: The trauma is present in the subject of the artwork. It is also about watching the trauma diminish through the process of the image's dissolution, leaving the final trauma in the discovery of what the resulting abstraction represents.

CJ: Could you speak a bit more about the processual aspect of your work? Uploading and downloading images a number of times, equal to the passage of days since a traumatic image was taken, seems like a ritual gesture. Do you imagine this action as a sort of ritual or rite for the dead? As a way of keeping vigil?

MA: I think this "vigil," as you said, holds two main interests for me. One is, as mentioned before, staying with the images and allowing them to work on me, a means of honoring them. The other is to emphasize the system's disruption on the data within the imagery. Shedding light on its power. Two contradictory aspects of the same process.

Someone once likened my work to the practice of Tonglen in Buddhism—where I become a conduit for the trauma, diffusing its effects. *Tong* stands for "letting go" or "sending out"; *len* means "receiving" or "accepting." Tonglen, a form of sitting meditation, intends to reverse our usual attempt and logic of avoiding suffering and seeking pleasure. As a response to the practice of Tonglen in imagery, I have spent hours with these images of suffering, death, and bitterness. A metaphorical breath in, absorbing the pain and disturbance within these images, and I breathe out an abstraction of digital artifacts.

CJ: After you have worked through the process of uploading and downloading these iconic images, they are eventually stripped of their representation function. Through the corruption of image file data, all original signifiers have become unreadable. This changes our role as spectators. We are no longer voyeurs of a moment of suffering, nor do we empathize through an identification with a human figure. What is our new relationship with these abstract images?

MA: I believe the very last steps of violence in the life of these images begin when the viewer forgets. This metaphorically occurs in my work when the original, horrific image is replaced with a pleasant abstraction.

I think our relationship becomes more about the way we look at such imagery than what that specific image has to offer or represent. It's not about the condition anymore; it's about the concept.

In an era proliferated with images and information, visual documentation of war and conflicts becomes less and less powerful. We know so much that we forget why we first sought the knowledge, and we see so much that it becomes hard to find clarity. The depicted repetition of traumas and wars causes the normalization of death in imagery.

When you look at the process within my work, each image has a very short life as a representational image. It quickly evolves into abstraction. I believe abstraction allows the image to cross political barriers and belong to everyone.

 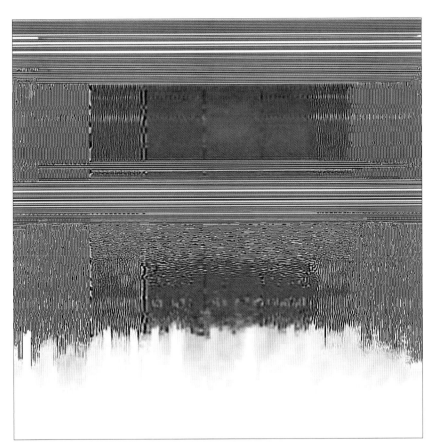

FAR LEFT
Mohsen Azar, *Alan Kurdi*, from *As of Now* (2018 to present), December 4, 2015. Image courtesy of the artist

CENTER
Mohsen Azar, *Alan Kurdi*, from *As of Now* (2018 to present), January 14, 2017. Image courtesy of the artist

LEFT
Mohsen Azar, *Alan Kurdi*, from *As of Now* (2018 to present), February 4, 2019. Image courtesy of the artist

"I don't think about photography's capability of capturing 'the real' trauma so much as I think of its capacity to hold signifiers of shared experience. To be reminiscent of, to remind."

CJ: In the canon of writings on photography, many thinkers, including Roland Barthes, Walter Benjamin, and even Sigmund Freud, have made connections between a concept of trauma and the act of photographing. The moment of an exposure or image capture is an event that originates in the Real, but immediately displaces it. We keep returning to the photographic image as an interpretive site, but its relationship to an absent event or subject is an unresolvable condition. Returning to the photographic image to restitute a lost or displaced encounter mimics the circuit of trauma, perhaps. Do you find a resonance between trauma and photography?

MA: I don't think about photography's capability of capturing "the real" trauma so much as I think of its capacity to hold signifiers of shared experience. To be reminiscent of, to remind. But in a way I agree that a photograph becomes a document of the moment in which the displacement of trauma occurs. A document of itself. A mirror to the trauma.

CJ: Susan Sontag famously argued in the 1970s that photographs of violence or suffering can elicit sympathy, but as we are inundated with images, we are likely to become desensitized and less connected to our humanity. At the end of her career, she revised her thinking and concluded that these types of images are "invitation[s] to pay attention, to reflect," and to ask questions about who made such horrific events possible. What are your thoughts about the ethos of images of violence or atrocity?

MA: I do agree with Susan Sontag's early statement, that there is a *desensitization* of the viewer in regard to traumatic imagery. With regard to viewership in my work, I seek to elicit an acknowledgment from the viewer—acknowledgment of our active role in the creation of the image itself.

CJ: In some instances, you have kept a journal of your thoughts and reflections as you upload and download a particular image. Why have you chosen to do that?

MA: While uploading and downloading images on Instagram, I observe the process of degradation. I take notes and describe in writing the way images are breaking down. Treating the images of violence and trauma as data, I count lines, dots, and shapes and report the changes in colors and the process of degradation. Taking moral and humanistic distance from the lost lives, I apply a descriptive analysis of the system of breaking down. The dehumanized and systematic approach taken in writing is not irrelevant to the way the very images themselves have been approached by the media and viewers: numbers and information.

CJ: Could you describe some of your upcoming projects?

MA: I have a few projects in the works. For one, I am working on a further evolution upon a series of digitally manipulated photographs, entitled *Landscapes*. In this series, I remove dead bodies from photographs of prominent, contemporary, worldwide conflicts, leaving behind empty and altered landscapes. These photographs become more palatable and less disturbing. The result is sometimes a vacant room or a barren landscape, void of the human figure.

The continuation of this project has two phases. First, reviving the photographs by re-creating the setting as a moving image. Second, making virtual reality environments from the moving pictures that allow the viewer a chance to interact within the reimagined landscape, becoming a part of them. This work will build upon the framework of my practice, examining the institution of seeing and the proposition of pain and protest in imagery.

Resurrecting images in this series as moving images recharges the essence of the landscape. It revives the setting after I have removed death from the reality of the picture—back to a time when the landscape was void of trauma. It is a time either imagined or real, before the true image was taken and posted in the media. In doing this, I demonstrate my thinking regarding the power and vulnerabilities of witnessing the photographic image.

The virtual reality experience is a re-creation of traumatic landscapes where these images were taken. These interactive virtual environments will act as an online archive accessible to the audience, who exist distant from the trauma. And also, they act as a way to heal the scene, replacing the lives lost in reality with the virtual lives of my audience.

CJ: This exhibition explores an expanded idea of "metadata." Does that concept resonate with you?

MA: As far as I understand it, in photography, metadata is the data that comes with the image. This definitely resonates with my work, especially the *As of Now* series, in the sense that it is an exploration of the reverse concept. It is an exploration of the data that we find when we *lose* the image.

Mohsen Azar (Iranian, born 1991; lives and works in the United States) approaches photography as part of an expanded practice. He utilizes social media processes, installation, and other media in his work that examines "the institution of seeing, the politics of presentation, and the possibilities of representation." Many of his works explore individual and collective responses to imagery of trauma in the digital environment. He has received his MFA in studio art from the University of South Florida and a BA in photography from Islamic Azad University, Meshkin Shahr, Iran.

Interview with Viktoria Binschtok

CHRISTOPHER JONES
March 29, 2021
Conducted via email

CHRISTOPHER JONES: I understand that, unfortunately, Berlin has once again gone into a lockdown because of the COVID-19 pandemic. This past year of crisis has taken a terrible toll around the world. I know that the shutdowns and closures have made producing and exhibiting work very difficult for artists. I am also curious if the pandemic and the experiences of the past year have offered any revelations or insights that will influence your thinking or the direction of your work even after the pandemic has passed.

VIKTORIA BINSCHTOK: The pandemic has been with us for a year and we in Germany are currently in a third wave. Of course the lockdowns have limited my work a lot. I miss the many trips and contacts that were part of my work. They always inspired me and were important input for me. The pandemic has certainly had a lasting impact on me and my work, but at the moment I'm not sure to what extent. It is still too early to make that prediction.

CJ: Your studies in art and photography began in the late 1990s and early 2000s, a pivotal time when the internet was becoming a dominant global network, traditional media was transforming into digital formats, and analog photography was becoming obsolete. Could you share why you were drawn to photography as a field of study and practice?

VB: Photography has always played a big role in my life, even before my studies. As a child, I emigrated with my mother from

CJ: In a later body of work, *World of Details* (2011–12), you utilized images from Google Street View (GSV). This unprecedented move by Google to create an interactive panorama of all of the world's public spaces was still relatively new at that time. You selected scenes from New York, such an iconic city, yet the images that you appropriated for your series are typically nondescript, banal locations. What was the criteria for the selections?

VB: I discovered GSV in 2008 and was immediately excited by the possibility to explore the streets of New York on-screen. The composite photographs have no defined borders and thus create the illusion of a panoramic view. This viewing experience was new and fascinated me greatly. I began to stroll the streets of New York City for weeks, discovering passersby looking into the camera along the way. They saw this apparatus on the roof of a passing car, which would hardly amaze anyone today. At the time, however, it was a new way of taking pictures that people didn't know about. They became part of a visual record without knowing anything about the further processing of the images. This astonishment of people in public places I found very exciting. I began to collect these scenes as screenshots and later came up with the idea of going to the specific places.

the former Soviet Union to West Germany. It was a great contrast to move from one political system to an extremely different one. We went from the metropolis of Moscow into a village setting. Suddenly there were codes that I didn't understand and, of course, the language barrier. I tried to decode my environment mainly through pictures—for example, through advertising images, TV, and magazines. In addition, my mother took a lot of photographs. I loved to take these pictures out of their shoeboxes to look at them again and again. I discovered something new in them every time. Later, as a teenager, I started taking pictures myself. Since my interest in photography was not tied to any genre, such as portraiture, architecture, or advertising, I decided to study artistic photography after school. My studies in the 1990s coincided with increasing digitization and globalization. This paradigm shift has certainly impacted my thinking and work. For example, in my installation-based work *Globes*, from 2002, I dealt with both: the new immateriality of digital images and their networked, global exchange.

CJ: You then traveled to New York to photograph the same locations as the Google images you selected, adding a performative dimension to the project. This creates a point of intersection between the "real" and virtual or digital environments. Could you explain the relationship between your photographs and their counterpart images created by Google's automated cameras?

VB: Yes, indeed, the project has a performative dimension through my journey. After months of working on-screen and appropriating GSV images, I had a great desire to photograph in the physical world. I wanted to combine zooming into the screen with my own physical movement to the same place. I also wanted to see these mediated places unfiltered, with my own eyes, and to see the surface of the city up close. So I flew to New York and traveled directly to the streets from my reference images using the coordinates I collected. These mostly inconspicuous corners represented to me crime scenes where people were randomly captured by the GSV apparatus. I was not interested in repeating GSV images by analog means. I wanted to discover something new. Therefore, I focused on details that were not visible on the screen—at least not at this level of photographic precision. A subjective, photographic view seemed exciting to me as a counterpart to the automated recording process of the machine. I wanted to create a different image in the same place in terms of color, form, and perspective. In my pairings of the series *World of Details*, I combine the diversity of the human/machine/image worlds.

CJ: In *Cluster*, a body of work from 2014 to 2017, and your most recent *Networked Images* series, you delve even deeper into an engagement with digital images online. In these projects, you combine your original photographs with images obtained through online search engines. Why did working in such a way appeal to you? What have you learned about how images are circulated and consumed?

VB: I had the idea to visualize the very abstract term "image flow" (or migration of images) in a concrete way. But I was missing the right tool for it until I discovered Google's algorithmic image search in 2013. For this search, I used my own photographs as a search image, instead of a search term, to extract similar images from the digital data flow. I appropriated these found JPEGs by restaging them and then compiled them as image families, including my source image. I thus transferred the search results into the physical world by rephotographing their image composition and thereby declaring them to be my images.

In *Cluster*, I thematized aspects of photographic representation, such as originality, duplication, authorship, materiality,

ABOVE
Viktoria Binschtok, *World of Details (crossing)*, 2012, inkjet print on MDF plate, 18 × 26 cm. Image courtesy of the artist and KLEMM'S, Berlin

OPPOSITE
Viktoria Binschtok, *World of Details (round corner)*, 2012, C-print, 116 × 147 cm. Image courtesy of the artist and KLEMM'S, Berlin

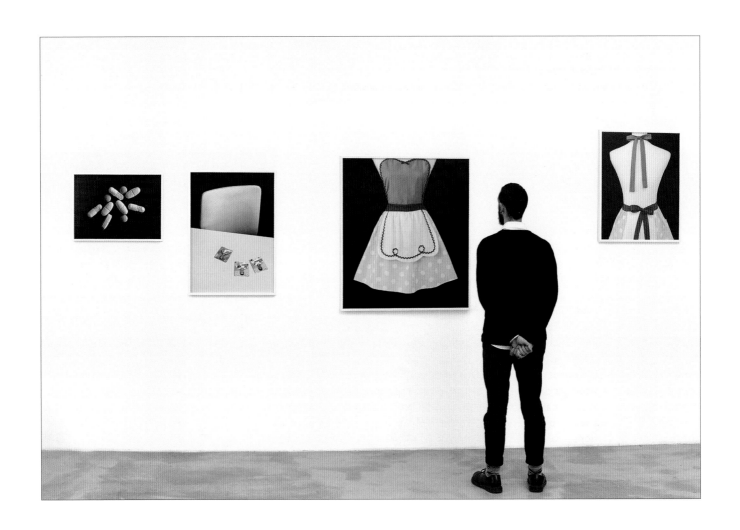

and immateriality. I connected images beyond language and context on a purely visual level. With this method, I wanted to visualize a random cross section of our current image culture. The image search algorithm became an important coworker, as it does not distinguish between supposedly important and unimportant content, as a human would. The machine filters emotionlessly for image analogies such as shape, color, and texture. This reveals a range of images beyond a content-related context that makes sense. So that was my interest: to look at these disconnected representations of our globalized world as purely visual phenomena. What quickly struck me was the frequency of product images. It is not surprising, however, that in a capitalist system, images are primarily advertising messages.

CJ: The algorithms used to interpret and process images online work by reducing formal elements (colors, vector lines, intensity) into numerical values for comparison. These unseen algorithms also utilize metadata, the information coded into digital image files, in their calculations. Your work seeks out ways to represent these unseen operations in a visible way. Why is creating this encounter for the viewer important to you?

VB: We live in a world that is permeated by algorithms. There is hardly an area of life that is not supported or determined by AI. Our knowledge is therefore based primarily on calculations that are provided to us by a few monopolists. I find this economization of knowledge problematic. In addition, digital processes are not visible to the human eye and therefore we can easily overlook their impact.

In my work, I use the medium of photography to visualize the networked structure that runs inconspicuously in the background of our reality. My work confronts viewers with purely visual information in order to depict this network of relationships in our interconnected society.

CJ: Your work is appealing on a visual level because of the strong links between formal elements in image groups. But we are also intrigued by the connotations and narratives we cannot help but read into your compositions. I am curious if you guide or orchestrate these "statements" or if are they purely happenstance. How much of your own agency do you assert? And how much do you abdicate to the search engine algorithms?

VB: By working with the image search algorithm, I see many images that I would not otherwise see. These search results are initially random finds—they are images by calculation.

In contrast, I select images from this pool quite consciously. I do not have any particular criteria by which I decide on an image. I'm interested in images that raise questions and cannot be easily categorized. I often achieve this openness of meaning through cutouts. I do not show the complete picture information but direct the viewer to details. Since photographs usually represent something concrete, something that we recognize from so-called reality, they therefore trigger associations.

My formal connections between images create narratives. I invent these relationships that are visually convincing but intellectually impossible to explain in any meaningful way. An ambivalence emerges between what we see and what we know. This search for meaning and the desire for authenticity still seem to be closely linked to the medium of photography, even though the possibility of constructing images is well known.

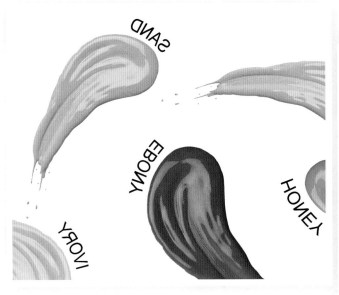

Viktoria Binschtok, *Ebony/Ivory*, from *Networked Images*, 2020, two digital C-prints, 55 × 125 cm each
Image courtesy of the artist and KLEMM'S, Berlin

Viktoria Binschtok, *Red Wine Man*, from *Networked Images*, 2019, two digital C-prints, 80 × 105 cm each
Image courtesy of the artist and KLEMM'S, Berlin

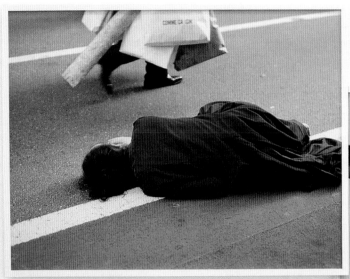

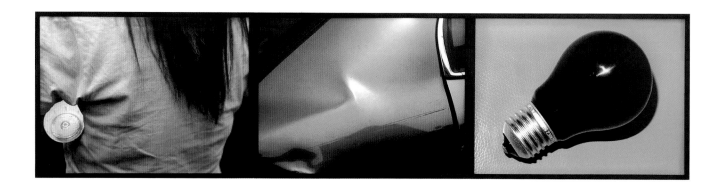

CJ: Image-interpreting AI and algorithms continue to evolve rapidly from year to year. How do these changes affect how you approach to your work? Did advances in these technologies play a role in your transition from the *Cluster* series to the newer *Networked Images* body of work?

VB: Yes, *Networked Images* has evolved from *Clusters* since 2017. As image search algorithms got smarter over the last few years and stopped showing surprising results, I had to change my search method. I no longer upload the whole image into the image search, as I did in the beginning. Now I select only a detail. Cropping makes my image more abstract and thus less "readable" for the AI. Therefore the search engine provides more diverse suggestions. Through this new method, my image and the found image only partially overlap. These matching interfaces between images are a way of visualizing networked information.

On our daily path through the information jungle, one link leads us to the next and so on. We usually follow the information sources that seem trustworthy. However, sometimes we get seduced by headlines or images and leave our original topic. Our global network yields countless possibilities to link different pieces of content. Since

nowadays everyone (who has access to the internet) can be a sender and receiver at the same time, private and public content is mixed. This aspect also appears in my work, in *Ebony Ivory* (2019) for example, when I combine an image of children's feet in the morning light with an advertising image of a cosmetics company's makeup palette. The image of the makeup palette, by the way, can also be read politically because it represents predominantly light skin tones. Here, subliminal racism becomes visible— simply through the limited offer of shades for people of color.

CJ: The relationships among images online are in a constant state of flux as new images are uploaded, shared, and edited endlessly. By contrast, your installations present static, physical objects in the gallery space. Why is it important to show your work in this way, as opposed to creating digital works on screens, for example?

VB: We consume images differently on-screen than in a physical space. Viewing images in gallery spaces allows us a slowed-down perception. Moving to an image in a space is also a bodily experience that does not work in the digital realm. My photographs often show objects larger than they actually are. This enlargement suddenly reveals details that would not be visible in small formats. In addition to the size, I also determine the form of the bodiless images. I transfer them into a solid state of aggregation and place them in relation to other images. This process of extracting found data from its original frame of reference, the internet, is an important part of appropriation for me.

My works represent the networked exchange of digital images. These images are snapshots of our current communication. The de-contextualization thus allows a compressed insight into the current image culture of our globalized world.

Photo-based artist **Viktoria Binschtok** *(Russian, born 1972; lives and works in Berlin) maps the image economy of our digital society, creating physical analogs for the flow of images online, immersed in a stream of incessant data. She has utilized Google Street View and various image search algorithms as sources for her work, intertwining her own photography into the logic of automation, and creating intersections between digital and physical space. Her work has recently been exhibited at the Weserburg Museum für moderne Kunst, Bremen (2021); Centre Pompidou, Paris; Henie Onstad Kunstsenter, Oslo; Kunstmuseum Bonn (2020); National Taiwan Museum of Fine Arts, Taichung (2019); Centre de la photographie Genève, Geneva (2019); Museum Folkwang, Essen (2017); and Fondazione Prada Milano, Milan (2016). She completed an MFA in photography and media arts and attained Meisterschülerin at the Hochschule für Grafik und Buchkunst (Academy of Fine Arts), Leipzig.*

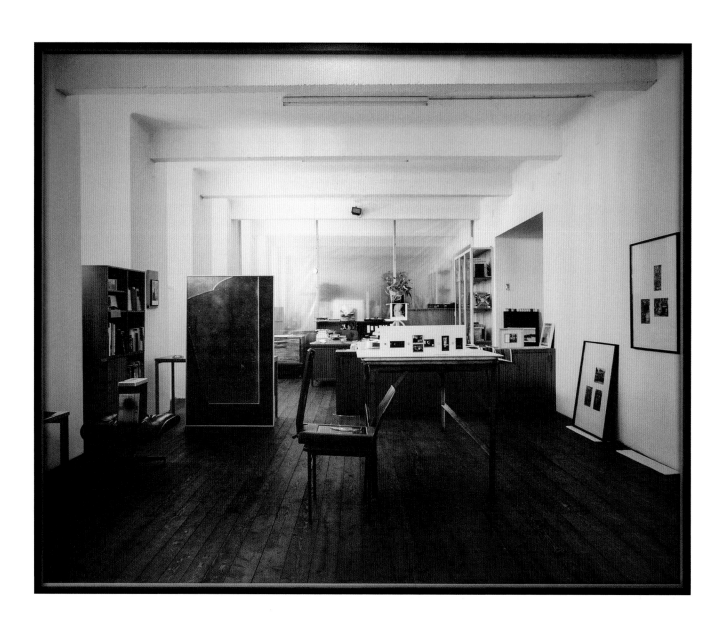

Interview with Mladen Bizumic

CHRISTOPHER JONES
October 29, 2020
Interview conducted via Zoom

Mladen Bizumic, *STUDIO (A Conversation with Joan Levin Kirsch) 1*, 2019, chromogenic print on Kodak Endura premier paper and museum glass, 114 × 140 cm. Courtesy of the artist and Georg Kargl Fine Arts, Vienna

CHRISTOPHER JONES: In our lifetime, we have experienced the shift from analog to digital. We might even say a shift from analog culture, aesthetics, forms of reproduction, and even social relations. Much of your work focuses on this transition. Why is putting pressure on those transitions important to you? What does it reveal?

MLADEN BIZUMIC: My interest in the transitional or transformative aspect of photography has to do with the nature of the discipline itself. It's very hard to pinpoint photography, to say: This is the material photography. This is the medium. This is the discipline. It is something that is polysemic—continuously developing and unending. My generation experienced that shift from analog to digital. We saw how processes and companies that dominated image production for generations started to disappear. This happened while I was at art school. The way to learn photography was to go to a darkroom, and we all used film. Digital photography hadn't entered mainstream image-making yet. I saw it around the year 2000 or 2001. Interestingly, Kodak actually had its most successful year in terms of revenue in 2000.

CJ: That was their peak.

MB: Ten years later was a different story. That was a shift in technology, but no one at Kodak could control from the position of the photography industry; it was a cultural shift. The internet began to change everything. It changed not only photography, but how music was distributed. It changed cinema; it changed politics. A lot of these fields are now interconnected. When these changes were happening, they didn't seem so sudden. Now, in retrospect, we can see that within twenty years so much was dramatically changed.

It is hard to analyze these changes when they are happening, so this one of the big challenges of art. My interest is not to make work dealing with the history of photography, how it was thirty or forty years ago. My interest is making work about how photography materializes certain cultural processes as they happen today.

CJ: Can you discuss the origins of your engagement with the Kodak corporation as a subject? It has been one of your key interests over the past decade.

MB: Since I was fifteen, I shot on Kodak film. I particularly liked the tone that you would get. I had a lot of Kodak film, paper, and other material that accumulated over the years. I was in the process of moving my studio and I saw these yellow boxes everywhere.

In the early 2000s, I was aware of the difficulties in buying certain films—for example, Kodak 160VC medium-format film was discontinued around that time. More generic films were introduced at that point. But then, the big news was the announcement of Kodak's bankruptcy, and with that my understanding of photography. This bankruptcy affected me on a personal level, but there was also the general discontinuation of a corporate industry, and that interested me. I didn't want to make work about loss. I thought that breakdown was also some kind of a breakthrough.

"We live in an extremely image-based society, so it is important to think about the history of image-making and the social relations around it."

I approached my Kodak project through the material in my immediate surroundings, but the repercussions of that process were global. It was not about image-making; it was about the entire analog infrastructure that was in question. And only now do we understand what that means. It was the process of deindustrialization and the introduction of a different form of communication: digital media. This changes not only how we experience the world, but also how we make art. All of these processes might seem quite abstract, but we have to realize every single worker was materializing those transitions.

CJ: Your 2016 exhibition at MOSTYN was titled *Kodak Employed 140,000 People, Instagram 13*. The installation featured the material culture and detritus of Kodak: 35 mm film canisters affixed to the walls, vitrines with cameras and photographic equipment presented as if they were artifacts, and camera-based chromogenic prints on the walls. You addressed the aesthetic and material aspects of analog image-making, but you also alluded to the shift from analog to digital as a reorganization of labor: a shift to a postindustrial form of image production. Our technology for creating images became obsolete as we transitioned into the twenty-first century and all of these workers at Kodak, or in similar corporations, were made redundant or obsolete.

MB: The title *Kodak Employed 140,000 People, Instagram 13* was borrowed from a book by Jaron Lanier. This was a critique

he made, but he has also been a pioneer in technology, coining the term "virtual reality." I was interested in Lanier, especially his comments on the development of image-making and the internet in general.

The project is really about an experience I had when I went to Rochester, New York. I realized that Rochester was a very prosperous city, the imaging capital of America, with two giant corporations: Kodak and Xerox. Rochester has much to do with the image culture of the twentieth century. Then I went to Harrow, an upper-middle-class part of London, where a lot of Kodak engineers lived. The factory employed around six thousand people and an entire city within a city was made near Kodak's manufacturing plant. You could see streets, gardens, playgrounds, schools—and all was connected to Kodak, this way of life.

Think about Instagram, which employed thirteen people when it was sold to Facebook in 2012 for $1 billion. In the same year, you have Kodak's bankruptcy. This was a culturally important moment, wherein one type of image-making disappeared and another became mainstream. We live in an extremely image-based society, so it is important to think about the history of image-making and the social relations around it.

OPPOSITE

Mladen Bizumic, *STUDIO (A Conversation with Joan Levin Kirsch) 3*, 2019, chromogenic print on Kodak Endura premier paper and museum glass, 114 × 140 cm. Courtesy of the artist and Georg Kargl Fine Arts, Vienna

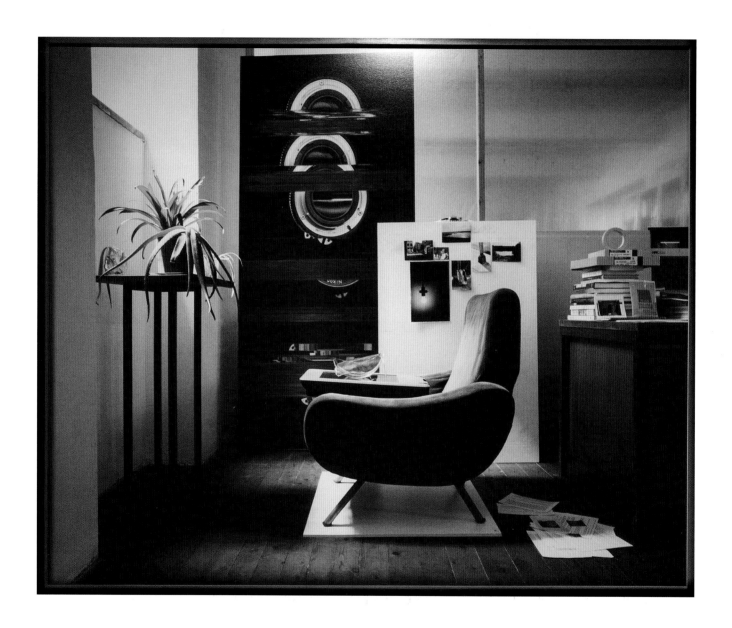

Like many artists, I am interested in an expanded field of art experience. For me, artwork is not only an image that is displayed on a wall, but also the "x" values that are attached to it: the architectural space, the duration of the show, the circumstances around the show, and so on. In my own displays or installations, I often incorporate objects that are not considered artworks per se. Some of my approach comes conceptual art. Many of my teachers were a part of the conceptual art movement of the 1970s; they were first- and second-generation conceptual artists. But my way of thinking is post-conceptual: the visual aspect of the art is equally important to the idea. The first-generation conceptual artist were not interested in the visual aspect or effect of art. They wanted to make a clear cut with the past because a lot of conceptual art was created as a reaction to what happened before, which was abstract expressionism. My generation is reacting to something else.

CJ: Let's discuss specific works that explore key moments in the transition from analog to digital image-making. One of your large collage works, *Picture Material (Rochester, NY)* (2008–13), is made of shredded photographs of a portrait of Steven Sasson. He invented the digital camera for Kodak in 1975, much earlier than most people realize.

MB: While I was in Rochester, I met Steven Sasson through Lisa Hostetler, a photography curator at the George Eastman Museum. We had lunch and I recorded my interview with him, which became part of my book, *Photo Boom Photo Bust* (2018). He told me his story of being an engineer in his early twenties, when he started to work at Kodak. For his master's thesis, he had already explored aspects of digitizing visual information. Sasson was brought into Kodak to work on this and had quite a bit of success, but it was crude, basic photography. He brought in his TV from home to demonstrate uploading an image to it, which took twenty-three seconds. The resolution was very, very basic, but this was the beginning of digital photography. Eventually, a corporation like Kodak, which made 90 percent of its revenue selling film, had to think about the future of photography.

CJ: What is fascinating is that Kodak more or less rejects this new invention because, as you said, their entire corporate culture was based on producing film, and this new digital technology threatened that.
MB: Steven Sasson told me that he demonstrated his digital camera to people from Kodak's various divisions. He would show them a photograph uploaded to a TV, a portrait. Someone from the marketing department held up a checkbook and asked, "But

can you photograph this?" And straight away, another potential use for this technology was seen. A number of people within the corporation thought about its possibilities and tried to refine what we call the "resolution" of the image today. There was some investment made at Kodak, but it was not serious. Sasson said that he was unhappy about the lack of enthusiasm for his invention. Only in the year 2000 or 2001 was there a recognition of how important this thing was, but by that point it was too late. You know the rest.

CJ: In a manner of speaking, Kodak invented their own demise by developing and patenting a digital camera, but never marketing or selling it.
MB: It's incredible. Basically they invented their own death.

CJ: For your project *MoMA's Baby*, you went further back into the history of digital imaging, connecting with Joan and Russell Kirsch. Russell was a computer scientist who invented the pixel in 1957 and created the first scanned digital image. How did that project come about?
MB: In 2008 I purchased a scanner, an HP Scanjet G 4050. It was used for digitizing analog photography: it was made to scan slides or medium-format or larger images. It was not top-of-the-line, but it was a

Mladen Bizumic, *Kodak Employed 140,000 People, Instagram 13*, 2016. Exhibition view at MOSTYN. Courtesy of the artist and Georg Kargl Fine Arts, Vienna. Photo: Dewi Lloyd

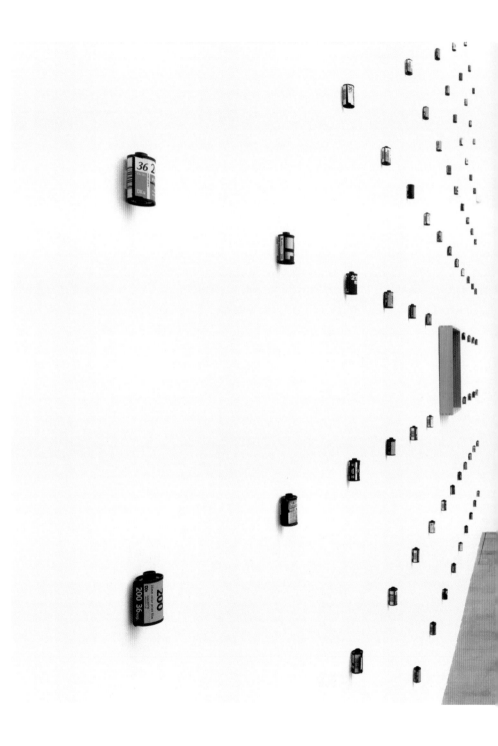

decent scanner. I did what most of us were doing in 2008. We understood that digital photography was coming, but we were not happy with what we were getting. There was a moment wherein you would buy a digital camera, start working with it, and then realize the images were not interesting. This was a transitional period for digital photography. Not long after that, smartphones entered the market and changed a lot of things.

MoMA's Baby came about by accident. I had to scan my ID and my HP scanner was somewhere in the cellar. When I brought it to my studio and scanned my ID, I saw strange patterns occurred all over my face. I realized they were fungus spores. There was some kind of mold infestation inside the scanner. I thought, "This is not very good." But then I looked at the image again and thought, "This is a very interesting image." I started to look into this object, a flatbed scanner. I found it interesting for a number of reasons. It was the only type of digital photography that I found appealing at that time. Somehow it was democratic. Whatever you put on it was scanned equally. Also you could scan images at extremely high resolution, then blow them up really large. For me, this was interesting; this was something I could use.

I started to explore. I had not taken good care of this scanner, and there were some cracks in the flatbed glass. Then I realized that every time I scanned, there was a reflection. That reflection was, if enlarged, quite beautiful. You could see multiple colors—like a rainbow. So then I tried to scan some reflective materials, and that led me to make a whole series, *ALBUM*. It is an ongoing series and it prompted *MoMA's Baby*.

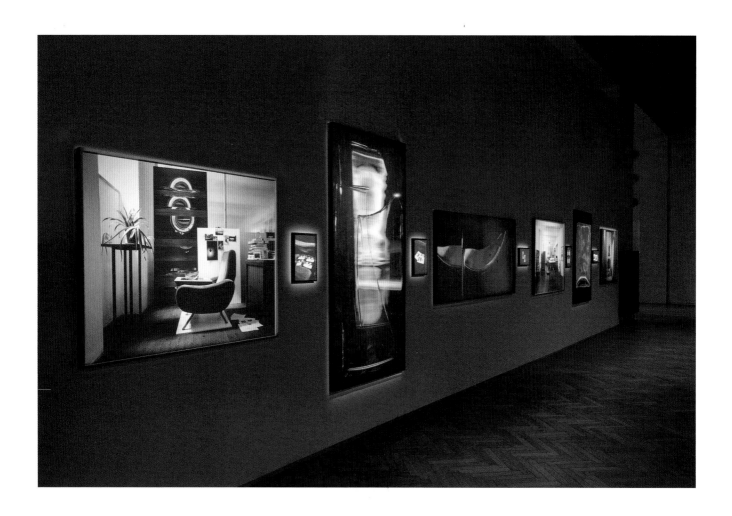

I wanted to learn more about the history of scanners and I found the name Russell Kirsch, who was still alive at the time. The story that I came across was like an introduction to this project: the first photograph ever scanned. It is a scan of Russell and Joan Kirsch's son, Walden, when he was four months old. I found Walden on the internet and sent him an email out of the blue. I said that I was interested in his story and would like to talk about it. He told me that his father, Russell, was the inventor, but now very sick. His mother, Joan, was very eloquent, and Walden gave me her email and encouraged me to contact her.

I sent Joan an email and soon learned that she was a curator and a trained art historian; she studied at Oberlin College, worked at MoMA, and so on. We set up a Skype meeting and that is how I started to learn more about her story. Joan was crucial for *MoMA's Baby*.

CJ: They are in a sense both the parents of digital imaging technology. Russell was the engineer, Joan the art historian. Russell was pursuing Joan and sought a way to connect with her interests in art and art history through his work.

MB: Joan speaks eloquently about the early days when they were dating. Russell didn't know much about art, but her life was defined by culture and arts in New York. He wanted to impress her, so he suggested that he could use computers to make a Picasso. By joking about this, they somehow came to talk about very serious topics, which eventually led to a number of collaborations. Joan was not directly involved with scanning the first photograph or inventing the drum scanner, but indirectly she very much influenced Russell's interest in visualizing the world by computer. At that time, computers were not dealing with these issues at all.

CJ: In some ways, their story echoes the origins of analog photography in the nineteenth century—a marriage of these desires, of the Western art tradition and industry.

MB: Certainly. They are a perfect couple in that they have different perspectives, but somehow one influences the other. As an artist working in photography, I find that quite often those issues are taken for granted. It's interesting to consider the motivations of the people creating these technologies. For me, talking to Steven Sasson or Joan Kirsch opens up a whole new perspective on what I can do as an artist. I'm interested in communicating a story, and for *MoMA's Baby* it was important to me to show those different perspectives, side by side, and to show what I think of as a photographic Rosetta Stone. It's really about the translation of one way of image-making, of seeing the world, into another way.

Joan Kirsch said something very beautiful. She said, "Changes in material change art." And you can see that in the work itself. I would have never made *MoMA's Baby* had I not had the chance to speak with her. Having had that talk kicked off many ideas for me. The production happened in my studio here in Vienna; she was sitting in Portland. I am sitting in this studio that can be seen in the background, and it became the foreground. This is how I approached the project: that often those background stories, those things that surround us, are somehow lost, and those invisible stories should be made visible.

Even the title itself is not about Walden Kirsch; it is about Joan. When I asked her how all this started, she said, "I was living in New York and I went to MoMA. I always wanted to be at MoMA. I'm a MoMA's baby!" This wonderful lady, she's eighty-nine years old, and she says, "I'm a MoMA's baby." For me, this was a wonderful metaphor for her life story.

Mladen Bizumic, *The Human Who Taught Computers To See 2*, 2019, gelatin silver print on Ilford paper, 36 × 24 cm. Courtesy of the artist and Georg Kargl Fine Arts, Vienna

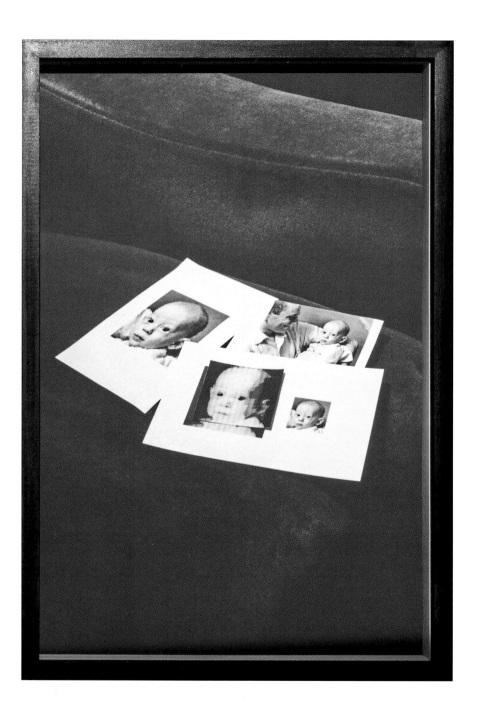

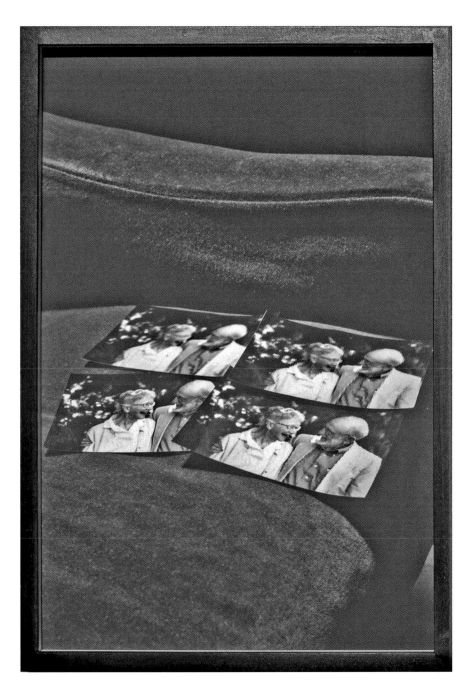

Mladen Bizumic, *The Human Who Taught Computers To See 1*, 2019, gelatin silver print on Ilford paper, 36 × 24 cm. Courtesy of the artist and Georg Kargl Fine Arts, Vienna

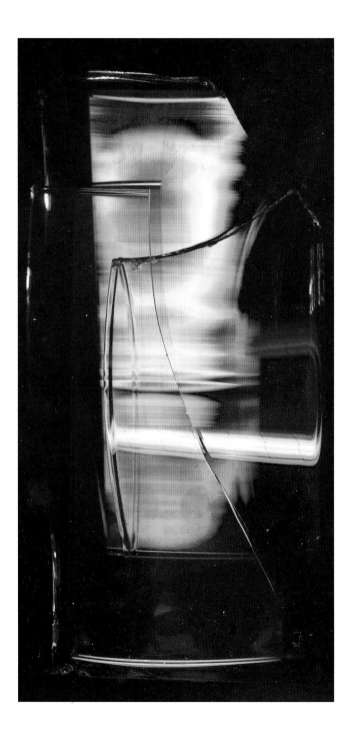

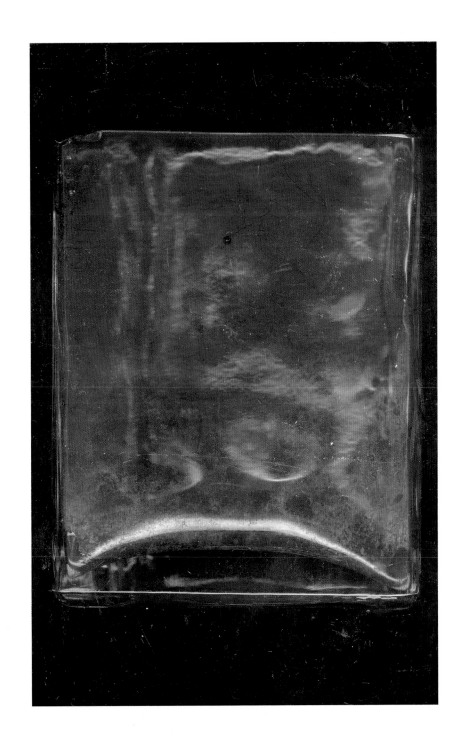

"It's really about the translation of one way of image-making, of seeing the world, into another way."

CJ: Foregrounding the backstory of the invention of digital scanning, the personal desires and relationships, making this information specific and visible, we could also think of that as revealing the metadata of digital imaging itself.

MB: Digital photography today definitely wouldn't exist without the invention of the pixel and the scanner, and Russell Kirsch was involved in both. The whole idea of a pixel, a square pixel, is a discussion that happened around a table—people sitting together and saying, "OK, we have to come up with the shape for a pixel." It is fascinating the things we take for granted. It's just decisions that were randomly made, sometimes really specifically. Sometimes it's about consensus, it's about somebody's idea, it's about somebody being pushy. We should bring those topics out and historicize them and question them. The world that we have today could look very different. And it may look very different tomorrow.

This is what interests me as an artist—not to generalize but to tell specific stories, and then to have an open metaphor for what this world *can* be. Opening that complexity and potentialities for interpretation is really important. Metadata is just one particular context where you can put this project.

CJ: I want to ask you about the ways that your images work together in *MoMA's Baby*. Some of them are recognizable as scenes from your studio, when you were conducting Skype interviews with Joan Kirsch. There are images of the portrait of Walden Kirsch, the first photograph scanned and translated into a digital form. And there are more abstract images related to your *ALBUM* series, where you are working with a faulty HP scanner. These abstract images remind me of work by László Moholy-Nagy, his camera-less images. They also resonate with Moholy-Nagy's advocating for a modernist experimentation with the apparatuses of reproductive technology. Can you talk about the relationships among the images?

MB: In *MoMA's Baby*, the large, color images that depict my studio are made with a medium-format camera. I also used it to depict a setting that I specifically made for a scanner in order to scan reflective pieces of material, different types of glass. These two moments in time are depicted together. The third set of images includes small, black-and-white pictures that I made using a 35 mm Nikon camera and hand-printed on gelatin silver paper. Those images depict documentation of photographs from Joan Kirsch—personal moments in the life of Walden, Joan, and Russell. I see them as a translation of each other; one wouldn't exist without the other. The eleven pieces in this project come together as a family.

CJ: I am intrigued by the ways in which you combine digital and analog aspects. You still shoot with film and often print photographs by hand, but there are interplays with a scanner or mediations between analog and digital. It reminds me of the anxiety in the 1990s and early 2000s about the supposed "death of photography" and the fear of the loss of photography's stability of authenticity. But if we look back over the long span of photographic technology, it was never one single format or method, was it?

MB: It was never one thing. That's why it interests me; that's why it's so challenging to talk about it in precise terms. It's not a material that is fixed. It's unfixed and it is something that existed before the camera was invented: the idea to build an apparatus to depict the world. We need to think about pre-photographic time in order to understand what photography might become in the near future. It's not only that photographs are taken by people—they're also taken by machines for machines. This is extremely interesting, that the anthropological side is being taken out of it, thus entering a whole new conversation about what photography will become. However, this transitional quality of photography is something that creates a lot of anxiety for people. For anything that is to do with a traditional understanding of art, our wish is to have something fixed—something fixed in time to something fixed in space. A range of practitioners in photography question this today. I see myself in conversation with artists who do similar things, but I also see myself reflecting upon a process that is related to much broader cultural conversations. That's why photography is so fascinating—because it is not only related to art.

*The work of Vienna-based artist **Mladen Bizumic** (New Zealander, born 1976 in Yugoslavia) explores the ontology of photography through an expanded practice that is informed by modernist and post-conceptual discourses. Bizumic probes the tensions between analog and digital, examining the material properties of the photographic in order to reveal the means of its production, distribution, and reception as marked by the social relations of globalization, corporate capitalism, and contemporary art. Bizumic has recently had solo exhibitions at Georg Kargl BOX, Vienna (2019), and MOSTYN, Llandudno, UK (2016). He was awarded the London Photography Residency of the Austrian Federal Chancellery in 2020; the Frances Hodgkins Fellowship at the University of Otago in Dunedin, New Zealand; and has been an artist in residence at the Künstlerhaus Bethanien, Berlin. Bizumic received a BFA and an MFA from the University of Auckland's Elam School of Fine Arts. He is a PhD candidate in art theory and cultural studies at the Akademie der bildenden Künste Wien, Vienna.*

OVERLEAF
Mladen Bizumic, *Kodak Employed 140,000 People, Instagram 13*, 2016. Exhibition view at MOSTYN. Courtesy of the artist and Georg Kargl Fine Arts, Vienna. Photo: Dewi Lloyd

Ida B. Wells

"a young boy wearing a hat and smiling at the camera", "confidence": 0.707644939

Microsoft

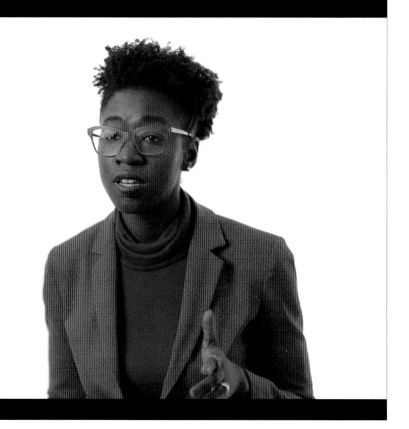

Joy Buolamwini

Joy Buolamwini (born 1989 in Canada) is a Ghanaian American computer scientist, artist, digital activist, and poet of code who works to illuminate the social implications of artificial intelligence. Her research and work as part of the Massachusetts Institute of Technology (MIT) Media Lab's Civic Media group have uncovered racial and gender bias in computer vision systems used by major tech corporations. Her efforts have exposed that these neural networks more frequently misrecognize or fail to identify the faces of people of color, particularly Black women. These findings have led to questions about how neural networks, created to sort and compare large sets of data, are trained and point to a lack of diversity in the images used to create their databases. They also raise serious civil rights concerns, as these processes are increasingly used in automated security applications and in police investigations to identify criminal subjects. For example, in 2020 Robert Julian-Borchak Williams, a Black man, was arrested in Detroit for a crime he did not commit because a faulty facial-recognition algorithm incorrectly matched him to another subject.[1] In response to her findings of inequality and bias in technology, Buolamwini founded the Algorithmic Justice League, an organization that combines research, art, and activism to unmask the harms and biases of artificial intelligence and lead a "cultural movement towards equitable and accountable AI."[2] Buolamwini's videos and spoken word performances have been included in museum exhibitions internationally, including the Museum of Fine Arts, Boston, and the Barbican Centre, London. A Rhodes Scholar and Fulbright Fellow, she has been named in notable lists including the Bloomberg 50, *MIT Technology Review* 35 under 35, BBC 100 Women, *Forbes* Top 50 Women in Tech, and *Forbes* 30 under 30. *Fortune* magazine named her "the conscience of the AI revolution." She holds master's degrees from Oxford University and MIT.

As part of this exhibition, *AI, Ain't I a Woman?* (2018) by Joy Buolamwini will be on view. This spoken word video highlights the ways in which artificial intelligence can misinterpret the images of iconic Black women such as Shirley Chisholm, Michelle Obama, Sojourner Truth, Ida B. Wells, Serena Williams, and Oprah Winfrey.

ALL IMAGES
Joy Buolamwini, video still from *AI, Ain't I a Woman?*, 2018. Courtesy of Joy Buolamwini

Michelle Obama

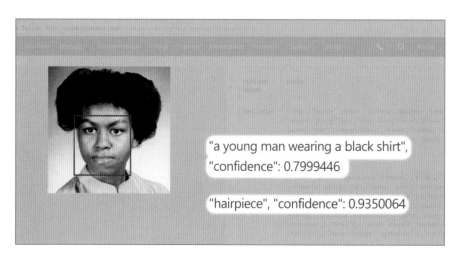

Sojourner Truth

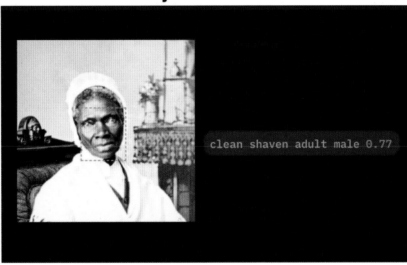

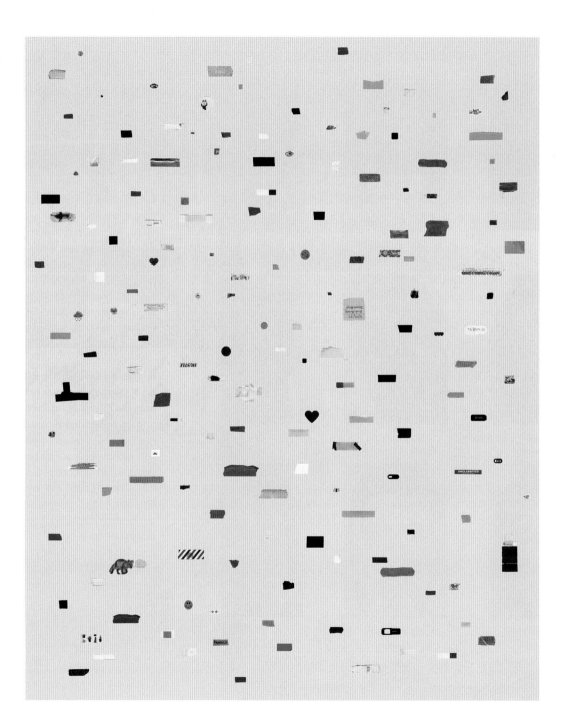

Interview with Ali Feser and Jason Lazarus

CHRISTOPHER JONES
December 17 and 29, 2020
Conducted via Zoom

Jason Lazarus, *Used Webcam Covers*, 2019
to present. Image courtesy of the artist and
Andrew Rafacz Gallery

CHRISTOPHER JONES: What brought the two of you into conversation about working together? What was it about the other's work or research that interested you?

ALI FESER: We've been in conversation about this project since 2013, when I started doing research on Kodak for my dissertation. Jason was part of developing that as a text-based, scholarly work. And our conversations have directed my research in a ton of ways. In that sense, this collaboration makes perfect sense—because he's had his hands in the project and we've been talking about it for so many years.

JASON LAZARUS: As an artist trained in photography, I am always looking outside of photography and at other mediums, and then outside of art in general, as key to understanding photography, of being an artist. I don't want to "white knuckle" handed down photographic histories and to make works that are in the grooves or the contours of what has been made. Ali and I share this interdisciplinary curiosity, even though we're each rooted in our trained birthplaces. As my work has become more collaborative with other artists over the years, or publicly engaged, this makes a lot of sense.

AF: We spent a month together at a residency at the Montalvo Arts Center. I was finishing my dissertation on Kodak and Jason had come in, dove in, and was swimming in my archive. The archive was mostly things that I had scanned and collected from multiple archives in Rochester, New York. The University of Rochester has Kodak's corporate archives, which span from 1882 to the current day: tour brochures, guides to the factory, corporate memos, annual reports, letters to shareholders, laboratory notebooks, test photographs, basically everything. The George Eastman Museum has George Eastman's personal correspondence and some of the company's early history. At the Visual Studies Workshop in Rochester, we have this giant treasure trove of slides made by Hymen Meisel, a former Kodak worker. I have hoards of newspaper clippings from the public libraries in Rochester, and just so much ephemera and visual culture from the corporation. I was also doing oral histories with retired and displaced Kodak workers, environmental scientists and activists, photographers and artists, as well as city residents in Rochester. From 2013 to 2017, I was in the field in Rochester and collecting as much as I could, from the archives and from conversations.

That process of Jason coming in and making different sense of my archives was just about the greatest gift anyone could ever give me. And then when we shifted to thinking about how to materialize this giant archive in a series of objects and images, Jason was able to take the reins in a different way.

CJ: Jason, some of the conversations that you and I had a few years ago got me thinking about the idea of "metadata" as a concept to reframe thinking about the discourse of photography. You described the inscriptions and artifacts on the backs of old snapshots and found vernacular photographs as metadata. Your anachronistic or poetic use of the term sparked me to think about metadata as a condition that has always been a part of photography, even prior to the digital era.

JL: When you asked me to think about considering proposing something for a metadata exhibition, it was a wonderful new thread where I thought, "OK, I kind of know what metadata is. How might I fit or not fit into that?" The idea of metadata was a sort of metadata itself. I was looking at everything and asking, "Is this metadata?" Rather than in a technical sense, I was thinking about metadata poetically, maybe even using it in a way that, to other people, feels misapplied. And then, fast-forward, there's this moment when I'm speaking with Ali, and she said, "Snapshots *are* metadata." And to me, that was huge. Ali said it in a direct way.

AF: I remember what you were referring to, Jason. The snapshot is metadata of the industrial process and of Kodak's layer management policies. How the emulsions on the film strip have been engineered and calibrated over the years in order to render certain kinds of images, certain spaces and certain subjects. This is metadata of the specific organization of labor at Kodak and of the ideologies of US industrial capitalism more generally.

I think there's also this other material sense in which film is metadata. Film is a chemical product and synthetic chemical manufacturing historically emerged out of an attempt to make things of value from the material waste produced by burning coal. From coal waste, you make the dyes that become colors in the emulsion of Kodachrome, for example. In this sense, photography as a consumer technology is metadata of industrial production more generally.

JL: We can also get at those moments through the protest signs that are part of the installation. People either thrown off or never having access to robust social welfare programs were a hallmark of what Kodak was for so many years. All of these moments are past the golden Kodak clichés that we're so familiar with. And there are symmetrical echoes in our digital regime.

CJ: George Eastman introduced the consumer-friendly Kodak camera in 1888, ushering in the culture of the snapshot and creating one of the most successful corporations of the twentieth century. A twenty-first-century counterpart would be Facebook or Instagram. Increasingly, we are more perceptive about the algorithms that utilize our metadata in order to influence what we see or experience on image-based, social media platforms. It seems we are still somewhat naive about the past: the ways in which the image regime of the analog or chemical era organized labor, resources, and social relationships. Do you think this project, the *Man and God* installation, makes contemporary connections as it excavates the past?

AF: Thinking about chemical photography helps us to understand what we mean by metadata, or what we mean about the social life of digital images. We can think about how Kodak attempted to effect a mass standardization of subjectivity in the visual sensorium. It was a standardization that was never complete. Workers don't always do what you want them to do; chemicals move around and don't always stay in the right layers of the emulsion. Film is this fantastically plastic and pliable media that can be pushed and pulled and made to show almost anything, but Kodak to an extent did standardize how we see the world and it charted chemical circuits of desire that we live within. We are also suggesting that subjectivity itself—and twentieth-century mass subjectivity in particular—is metadata of the industrial process.

JL: But there is also a graceful approach to metadata. Like when you pick up a camera, how could you not want to photograph your loved one with saturated color? Or to monumentalize or archive a rare moment when a family is together over the holidays? The love and the affection, and the fantasy and the desire will always be the keys to unlocking the projects of mass capital. How can you blame us? When Ali and I talked about doing this project together, we decided not to do a "criticality-only" project about Kodak. Let's have humility and grace and acknowledge that we are all implicated in this. The criticality is not interesting without a deep appreciation for our need to express ourselves and feel connected.

CJ: I think that is an important perspective to maintain. We also have to consider one of the promises of photography itself: there is a democratic impulse, an invitation to participate. When we look critically, we can start to reveal those power structures and hierarchies, the strategies of control and social relationships we are interpellated into when we participate in snapshot culture or share images on Instagram. The invitation to participate, to self-represent oneself in the world of images, albeit never perfectly realized, is still a key appeal of the premise of photography.

AF: I think that's a good point and another example in which analog photography can help us understand the digital. We can look at Kodak absolutely as democratizing image-making. With Kodak, anyone can photograph their loved ones and share how they see the world. At the same time, Kodak achieved monopoly status by consolidating and concealing the means of production and the industrial process. Kodak detached consumers from the actual manipulation of chemicals and made everything secret. Now think of digital images. There has been this opening up of the potential to make and share images again, but how would we describe what is happening to the means of production now? What is happening to our capacity to intervene in those images now?

CJ: Let's reposition for a moment and think in terms of the site-specific installation that you're creating for the exhibition, *Man and God*. I think that a lot of visitors may be surprised to encounter this kind of work in an exhibition that is grounded in our photography program. Rather than framed photographic prints on the wall, there are objects and sculptures related to photographic materials, sounds and projections of a metronome, recordings of whistling. This is an experience that activates more of our senses than just the visual. We can call this an expanded photographic practice, but how do we help an uninitiated viewer get a purchase on what that means?

JL: It's more like inviting viewers into a storm cloud, where there's live wires or live connections that are able to be activated. I think the conditioning of how we image love or desire or landscape or ourselves is at times both democratic and restrictive. We might restrict ourselves more than we realize because we're trained by corporations and the media on what images of love look like. Whereas we feel we're expressing ourselves, perhaps we're really following a sort of emotional algorithm. As an artist, to break out of that is an instinct. If I'm looking at other work as a viewer and I'm seeing what I expect to see, I feel that maybe I'm missing something or I'm not fully engaged.

AF: This is something that Jason's been thinking about and doing for a long time—working in extra photographic registers and media. However, there is an analogous relationship between the move from vision to sound and sculpture to the way in which the ideologies and organizational forms of industrial capitalism, through Kodak's commodities, extended beyond the factory into other domains of life.

As opposed to images, within Western epistemologies of the senses, with sound one can't necessarily control hearing. We have all these different loose things coming into our ears. We might not be aware of what we're hearing, but nevertheless the song can get stuck in our heads. We find ourselves moving to rhythm and only then do we realize what we're listening to. I think by moving into these different sensory modalities, we're thinking about the depths to which Kodak rearranged our visual habitus or visual sensorium beyond what we could rationally select from an image. For me, that's partially what the music is doing. We've talked so much about the metronome and the whistling and wanting those sounds to radiate through the galleries. It's a way to spatialize the breadth of Kodak's influence and also the temporal lag of its influence. Film is obsolete, Kodak is just a shell of what it was, but it still shapes our visual habitus and our fantasies, like how sound waves continue to move and linger in space beyond one's physical encounter with the sound.

CJ: One of the core components of the *Man and God* installation is the story of Leopold Mannes and Leopold Godowsky Jr. They were two professional musicians who were also fixated on the idea of creating a stable color photographic process. They pursued this obsessively in their spare time and were ultimately hired by Kodak to work in Rochester. They ended up creating the Kodachrome process, the first stable color film for consumer use. Working in the darkroom, they found that as musicians, it felt more natural to synchronize the chemical processes by whistling Brahms together, rather than using a timer. Why was this such a compelling narrative for the project?

JL: This relates to an earlier conversation with Ali about working in the darkroom and the sounds of the darkroom. It's a funny thing because you hear soft technical noises or clunks or clicks. It is something I hadn't thought of before. In the darkroom, you're working in total darkness, so you're very on edge. If you're working in a gang darkroom, you have to call out what you are going to do so that you don't bump into each other. There is a choreography and if you don't do it, you risk bumping into someone or ruining their print. In discussing the Godowsky story with Ali, this sort of whistling was so anecdotally charming. It's hard to explain, but it's another aspect of image production that no one ever talks about.

That felt connected, the idea of whistling as a kind of symphonic relationship. These two people had a connection outside of photography that allowed them to

have handrails in the darkroom. It helps me to understand photography by thinking about the darkroom as a social space and as an acoustic space.

AF: The appeal is also the delight of thinking about how visual technology is synesthetic. It's crossing through sensory regimes; with Kodachrome, music is encoded into the photographic emulsion. The symphony is cinematic, with swelling timpani, and there's a romantic, conversational duet between oboe and flute. These are rhythms of industrial production and they are wrapped into the aesthetics of Kodak film. I'm thinking of the tagline—Kodak: For the Times of Your Life. Kodak wanted consumers to document their lives like movies, as narrative through time. But we're not limited to the rhythms of the factory or the melodies of Brahms's symphony. Emulsion can always be manipulated to produce a contrapuntal articulation of this ideological formation.

CJ: The *Man and God* installation draws on so much of your research, Ali, into the Kodak corporation and its management, hiring practices, and labor relations—even the impact of chemical pollutants on the environment. All of these political and structural issues had a far-reaching impact. But you've also included material from a found archive of personal photographs by a Kodak employee, Hymen Meisel. What about that material appealed to you?

AF: Hy was an employee of Kodak and an amateur photographer. He took classes at Kodak and submitted his photos to Kodak photo contests. I've come across mentions of the prizes he won in the *Kodakery*, Kodak's employee newspaper. There's something democratic about these photography classes and contests. You had factory workers, research scientists, managers, nurses, phone operators—all learning and practicing photography together. They created possibilities for a sense of solidarity or, at least, mutuality among employees across hierarchical lines.

But Hy's archive is also a rich, idiosyncratic testimony to how someone lived his life and saw the world. There were a few rolls of film where it seemed he was experimenting or trying something new, taking photos of his reflection in melting muddy puddles in downtown Rochester. Maybe he was practicing something he'd figured out in class? Or it was an assignment? There are several rolls from the 1960s and 1970s during urban renewal in Rochester. He documented the destruction of old churches and mansions and the construction of the new road system. What really excites me about Hy's images is that they're not family

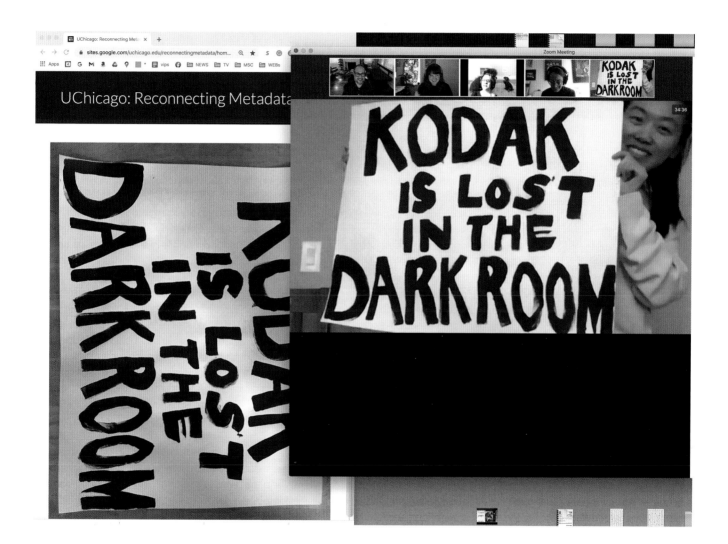

photographs. Family is overrepresented in the visual culture of Kodak. Hy's archive images a different but very rich kind of sociality—lots of cousins, friends, siblings, and one-off travel buddies who he met in Panama, Europe, or wherever.

Something else that I find incredible about Hy's collection is that toward the end of his life, he was making photographs of his TV. On the final few rolls, there are images of inaugurations: Johnson, Nixon, and Carter. He gets a new TV set halfway through, so you see that change. After all of Hy's travel shots and all of his street photography, the images of mass historical events on his TV are a reminder of the fact that film was a celluloid circuit that united public history with private and personal memory. It shoots the mass historical into the intimate and personal. These images of the inaugurations were mediated by television, but they were still an immediate part of Hy's sensory environment, as much as the old churches and the new roads.

CJ: I want to touch upon a unique aspect of the installation that involves social practice or social engagement. You have come across photographs in the archive that document public demonstrations

and protests over the decades against policies of the Kodak corporation. These are community responses to issues such as the company's racialized hiring and promotion policies. You are hosting workshops to invite participants to re-create signs and placards used in these demonstrations. Jason, this is a strategy you often use in your work. Could you explain why activating these protest signs in this way is important?

JL: It is a good time for this history to become more visible, especially in the wake of Black Lives Matter. To refabricate the signs, to create a facsimile, the participants of the workshops have to look at the images and look at the signs' relationship to the body. It's kind of a "reverse" photography, going from an image to a sculpture.

How do we do something other than present this history in a museumological way? As an artist, I was intrigued by this form of engagement. It's another twist of the screw, another way to become more intimate, and for the experience to be bodily as opposed to the way that photographs are commonly presented—especially in a museum context where things are super sanitized and sealed in glass or plastic. This is a way of leaping through the photograph and getting back to the body.

The participant who is re-creating the sign has to identify something that they feel particularly attracted to or in solidarity with. It becomes a political lens or a relational mosaic through which you're seeing the signs. People choose signs from the project archive that they want to re-create. The participants' choices add a contemporary layer as they ask themselves what it is in these messages that they respond to or wish to be close to.

Ali Feser (American, born 1984) is a cultural anthropologist trained at Bard College and the University of Chicago. Her research is situated at the intersection of visual studies, science studies, queer and feminist theory, and the anthropology of late industrialism. Her book manuscript, "Reproducing Photochemical Life in the Imaging Capital of the World," is an ethnography of US visual culture, industrial capitalism, and political fantasy through a material history of Kodak film.

Jason Lazarus (American, born 1975) is an artist exploring vision and visibility. His work includes a range of fluid methodologies: original, found and appropriated images, text as image, animated GIFs, photo-derived sculptures made collaboratively with the public, pigment inks as image, live archives, LED images, and public submission repositories, among others. This expanded photographic practice seeks new approaches of inquiry, embodiment, and bearing witness through individual and collective research and image production. Lazarus's work has been exhibited widely and featured in venues such as the San Francisco Museum of Modern Art; Art Institute of Chicago; MASS MoCA, North Adams; and George Eastman Museum, Rochester. He has an MFA from Columbia College and is currently assistant professor of art and art history at the University of South Florida.

OPPOSITE
A photograph from the Hy Meisel Slide Collection at the Visual Studies Workshop in Rochester, New York. Meisel, a lifelong resident of Rochester, photographed his personal and professional life, creative scenes, and his city as it changed over the years. Image provided by and courtesy of the Visual Studies Workshop, Rochester, NY

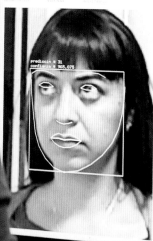

Interview with
Rafael Lozano-Hemmer

CHRISTOPHER JONES
January 28, 2021
Conducted via Zoom

CHRISTOPHER JONES: You have had a busy year with the release of a mid-career monograph, *Rafael Lozano-Hemmer: Unstable Presence*, and major solo exhibitions at the Museo de Arte Contemporáneo de Monterrey in Mexico and the San Francisco Museum of Modern Art. Has the SFMOMA show been postponed because of COVID-19?

RAFAEL LOZANO-HEMMER: It's postponed. It's going to happen in November 2021. My exhibition, a big retrospective, had to be brought down in size. It had artworks like *Vicious Circular Breathing* (2013), which is the one where you are invited to breathe the air that has already been breathed by everybody before that. Can you imagine that work in the context of COVID-19? It was a no-go.

CJ: I was thinking about that work and how the context for it has radically changed in the era of COVID-19. So much of your work is predicated on people coming together in person, in the space, and having a participatory experience as a group. There are tactile aspects that are important. I'm wondering how you have changed in terms of your thinking and how you are planning for the future. We're all assuming that COVID-19 will subside, but has this permanently changed your strategies in terms of how you put together installations?

RLH: Temporarily, definitely. The work that we did throughout lockdown has been online pieces. We did an online memorial, *A Crack in the Hourglass* (2020), for the victims of COVID-19, where people can send a photo of their lost loved one. We render that in real time using hourglass sand, then it erases the portrait, it covers the sand, and

then draws a new one. This process is not a replacement, but it is answering the question of, at a time of social distancing, how do you cope with the fact that, for example, your dad went into the hospital with a cough and two weeks later he's died? You never saw him. He never saw you. It's crazy that we can't get closure.

The memorial work is going well. I think that we, all artists, work with a sense of presence and a sense of participation. I miss the hormonal and the group, experiencing a shared experience. We also work with the symbolic, and the symbolic matters. I think that it's a project that has a use. I always passionately defend the uselessness of art, but this one in particular has been useful. Two hundred and seventy families have participated so far and there's a dedication and obituaries part of it. We've received a lot of feedback about how it has helped them reach closure.

There's one thing that we did for my *Pulse* pieces. A lot of the work I do is measuring people's biometrics. To measure a pulse, typically you're holding onto a sensor or doing something with your finger. We developed a live photo plethysmography system that allows your heartbeat to be extracted from a webcam, either in your phone or on your laptop. You just look at it and the system detects small variations in the tone of your skin to find your heartbeat. This has existed for a while. To my knowledge, no one had ever done it in phones and laptops. We used that as the basis for

a new online piece called *On Pulse*, which is a 3D avatar world wherein your avatar is made from the information we extracted from your heartbeat.

For the next pieces in the *Pulse* series, we're using photo plethysmography so there's no contact, no touch. To be honest, the moment that this is behind us, I want to go back to touch because there is something fundamental in haptics and in that magical reality that I want to recover. For now, that's how we've reacted to COVID-19. We took existing pieces and we reengineered them with no-contact technology. Then we will make new pieces which respond to social distancing.

Thinking in terms of after the pandemic, I'm a militant. I'm a militant, take-over-the-streets person. I think that we need to reembody our cities and we need our bodies to be out there. We need to kiss strangers and we need to share our experiences. I often talk about Frederic Rzewski. He's an American Marxist composer whom I admire. He talks about how the most important objective of art is coming together. It's bringing disparate people to share an experience and there's something political about that. There's something practical about it, seductive about it. It's the fundamental role of culture to create community. It is what artists do. I miss that, but I also know that it's going to come back with a vengeance.

CJ: You have begun using cameras in your work in order to read the biometrics of those interacting with your artworks. Even though the context of the installations is about inviting participants to willingly share in a copresent experience, it's also a reminder of our culture of surveillance. Surveillance has been a leitmotif in your work from your earliest projects. For example, *Surface Tension* (1992) featured an ominous, disembodied eye following the viewer by way of a tracking system. Could you discuss your thinking on surveillance and how it has changed since your early works?

RLH: It's become more confused. I'm comfortable with confusion. I have many, many notes. The first is that I am completely for banning face recognition in all activities, except for art. I think art should remain the only place where face recognition technology should be available because it is a technique that we can use in a critical and poetic way. Let's start at the beginning. The first artist who ever used surveillance in an artwork was Marta Minujín. Before Nam June Paik, before Dan Graham and Bruce Nauman and Julia Scher, the very first time that, according to historians, there was an artwork that included a live camera, beaming live images and mixing them into an art installation, was Marta Minujín's *La Menesunda* (1965). The reason I love to talk about Marta Minujín is because, first of all, she is a pioneer of video art and surveillance who is a Latin American woman. That's cool to break the stereotype of Frida Kahlo. Second thing is it was over fifty years ago that this happened. To think of using surveillance or tracking or video cameras as new media is so absurd. This is a tradition of experimentation that goes back a long

time. If we agree that the artwork is aware, that the artwork is alive—don't think of it as an emergent phenomenon. You don't need technology to do that; an artwork has an active role.

That role is shared with the spectator, as Marcel Duchamp said, "It is the look that makes the painting." All artworks have awareness, and we've always known that. Now, through cameras, through microphones, through sensors, it is the artwork that is listening to you. It's looking at you, is expecting you to do something interesting with it. This raised awareness of the artwork is something that I'm super interested in. It's not a closed system. It's an open system, an incomplete system. That's what those cameras are there for.

Regarding the oppressive usage of surveillance, Manuel DeLanda's book *War in the Age of Intelligent Machines* (1991) was how I got my information about the transfer of executive control from closed-circuit TV. There was always an authority on the other side of the monitor that reduced reality to intelligent bombs. An intelligent bomb, the cameras now have imbued in them the prejudices that we have in their target acquisition, racial identification. DeLanda talks about that moment, where these bombs are making executive decisions and the human is removed from it. That's the kind of surveillance that we're dealing with now. Artists such as Trevor Paglen are concerned

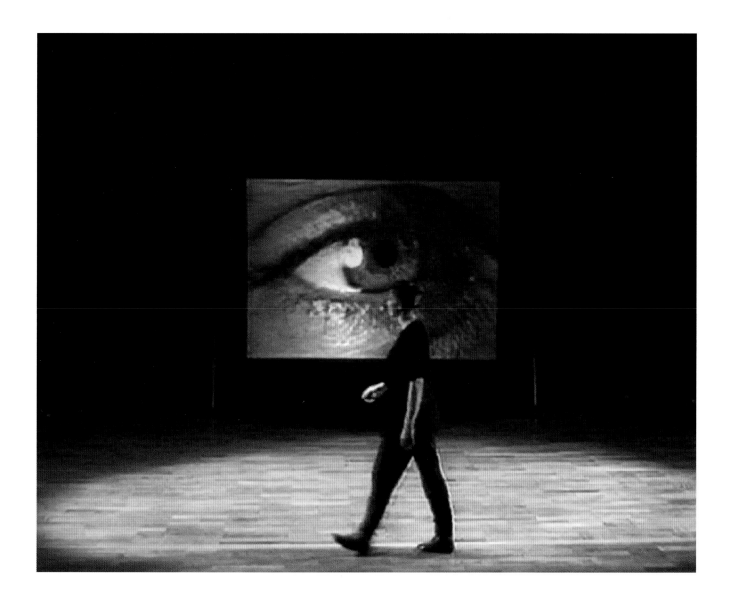

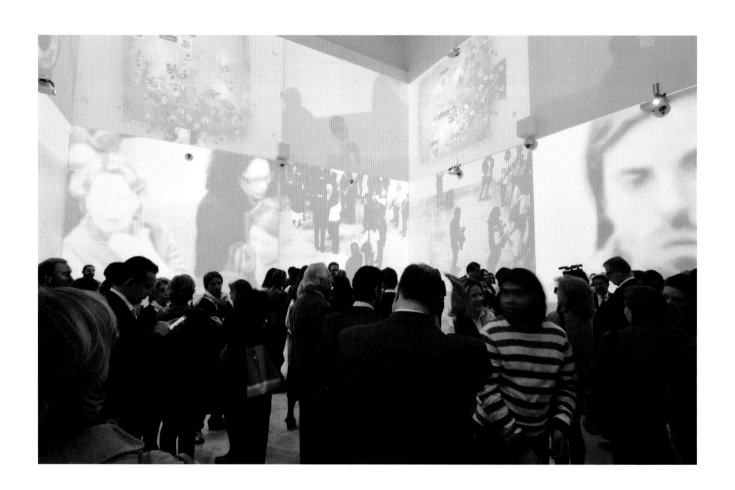

about that surveillance inheriting all of the prejudices that we have. There's nothing neutral about it.

Why do we use surveillance? One reason is to make it material, to make it evident. How do we turn surveillance, which usually makes our image small, into a kind of observation system, into something that's tangible, something that's corporeal, something that is symbolic of its relationship to us and its insidiousness? Visualizing, materializing is a big part of what I do. The other thing that you want to do is to take these technologies and pervert their original usages—not to create suspicion, but to create connectivity. There are ways in which disparate realities can become entangled or ways in which an artwork can actually take place in two sites at the same time—the remote presence. I think it's prudent not to think of surveillance as one thing. It is an entire constellation: a philosophy and a language and, of course, it is internalized.

The selfie and the Zoom call form part of this atmosphere. It's an atmosphere that remembers. There are political, practical,

and aesthetic issues at play with this kind of atmospheric surveillance state. There's also an economy of surveillance and metrics. It depends on the artwork. If you tell me which artwork has a camera, I will tell you why it's there and what am I doing: to be not just passive, to not extend the domain of those technologies of control, how to pervert them, how to make fun of them, how to make them tangible, how to make them connective. These are different approaches to what can and should be done with surveillance.

CJ: The interactive installation *Zoom Pavilion* (2015) brings your engagement with surveillance technology to a high intensity. You're using facial recognition algorithms to create real-time analytics and video projections of participants.
RLH: *Zoom Pavilion* looked at a very specific historical case: the rules of assembly in public spaces in communist Poland, as well as the life and experience of my collaborator on this project, Polish artist Krzysztof Wodiczko. Wodiczko has been working in video projection mapping for over thirty years. The project is informed by the fact that in communist Poland, there were regulations as to how many people could gather in public spaces and how far away they needed to be from each other in order to determine if the activity was suspicious or not—if it was an illegal assembly.

We took these rules from communist Poland and articulated them technically. In this piece, we're not just tracking individuals; we're tracking the relationships of individuals. How far are they from each other? Then we made a call on whether

that proximity for that amount of time was suspicious or not, and we tracked it in an archive. It's a very old-school kind of technology, but it's not unlike *Vicious Circular Breathing* in the sense that your participation makes you complicit. Everybody pulls out their phone and they become part of this sealed environment of surveillance. It's a panopticon.

CJ: When you see people engaging with these installations by taking selfies and posting them to Instagram, do you feel that they've missed the point?
RLH: I think they're being immersed in a logic of control. They are, whether consciously or subconsciously, understanding the reach of this. You have an experience of immersion in that world. I can't control how people will see it, but I hope that this creates a little bit of a vaccine or an antidote. The Brechtian in me would say, "This is a shakedown so that you can come out and say, 'Holy shit. What kind of world is always recording us?'"

There's also some poetry, some seduction, and this idea of being counted, which I think is interesting. There's a question of visibility. It depends on the work. *Zoom Pavilion* is more dystopian—it comes specifically from a dystopian moment. It also speaks to our contemporary moment, which is quite dystopian too. However, in other projects we redirect surveillance technology to different ends, and *Level of Confidence* is an example of them.

Facial recognition engine: Fisher, Eigen, LBPN **Detected similarity score:** 334.692 points
With the face of disappeared Ayotzinapa student: Alexander Mora Venancio
Level of confidence: 16 % **Result:**

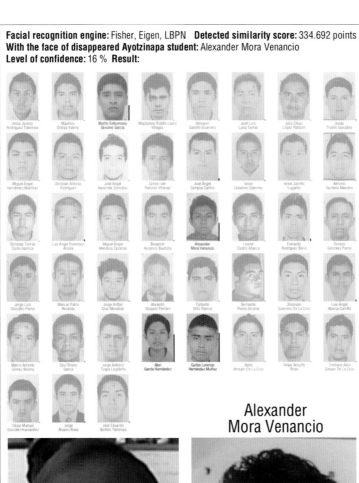

Alexander
Mora Venancio

CJ: *Level of Confidence* (2015) addresses the kidnapping and disappearance of forty-three students from the Ayotzinapa Rural Teachers' College in Iguala, Mexico, in 2014. What compelled you to make this work?

RLH: As a Latin American who lives in Canada, in a very different context from my colleagues, I'm careful about overtly political works. Some of the worst intellectual crimes have been committed in the name of political works. Also I'm allergic to the idea that a lot of us, me included, should benefit or are seen to benefit from political traumas and dramas.

There is a certain opportunism that I'm careful about. I know for a fact that it is not OK to make an artwork out of the disappearance of forty-three seventeen- to twenty-one-year-olds and create status and profit from that. At the same time, I am a citizen. As a citizen, I have to react. When I heard that the forty-three had not been found, that there was no forensic evidence, that the established story of the government was not true, that the communities and their family members were still searching for them, I said, "We routinely work with algorithms for face recognition. Let's make an artwork whose entire job for the rest of time is to look for these forty-three people." That's what this piece is about. I don't call it an artwork; I call it a campaign.

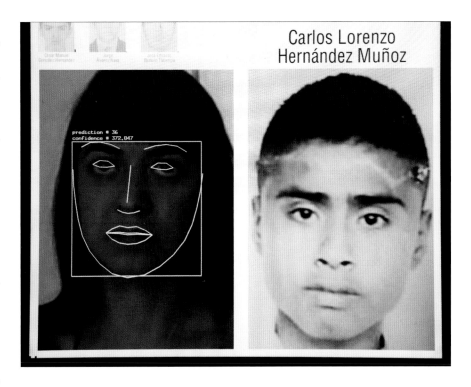

OPPOSITE AND ABOVE
Rafael Lozano-Hemmer, *Level of Confidence* (detail), 2015, face-recognition algorithms, computer, screen, and webcam, dimensions variable, edition of 12, 1 AP. Shown here in Montréal. Courtesy bitforms gallery, New York. Photo: Antimodular Research

Level of Confidence differs from the opportunistic art that I was complaining about. It is designed specifically as a campaign that is free and downloadable by anyone. You can go onto my website and download all the software, including the source code, to be able to run the piece. This means that it's run in over a hundred universities, foundations, galleries, museums, and libraries around Mexico, and also around the world.

The spirit is to keep the search alive. The tolerance that we have for the flavor of the month goes away, but there's still no answer to where these kids are, so the search continues. How do we continue talking about this?

The second objective is the generation commiseration. You look at yourself and you're being tracked by the algorithms in the artwork, and there is a sensation of connection. These are not *others* who have disappeared while you remain safe. This could be you. The next misuse of control may happen to you. To find similarities between yourself and these kids is an important political aspect.

Then there is the fact that the work does not produce results. It says, for example, "You look the most like Martín Getsemany Sánchez García," one of the missing Iguala students. The level of confidence is 17 percent and results are thus not found. But the search extends through your private self. How much you search inside of yourself is an interesting question.

There is also a question of generation of income. Whenever this artwork is presented

or sold (it's been collected by the Museo Universitario Arte Contemporáneo in Mexico City and Musée Giverny Capital), the entirety of the proceeds go to the family members of the disappeared. We have sent tens of thousands of dollars to help them with forensic services, to help them with lawyers, to help them with their caravans, and so on. This is an important financial contribution.

The last element is that source code can be changed. We're working with Indigenous programmers in Canada to create a piece that will look for over one thousand women who have disappeared from Indigenous communities in the past five to ten years in Canada. The idea is that it can become a general purpose tool. We are also working on this in collaboration with BIENALSUR in Buenos Aires.

CJ: You've taken this technology of surveillance and control, opened it up, and turned it back in on itself to create a gesture of human connectivity and memorialization.

RLH: We're now making a version to look for the disappeared under the dictatorship in Argentina. We want to make this a general purpose tool—not to search for suspects, but to search for the disappeared. That's the key contribution of this piece. It's meant to have all those different stages. I'm very proud of that project—

RIGHT AND OPPOSITE
Rafael Lozano-Hemmer, *Level of Confidence*, 2015, face-recognition algorithms, computer, screen, and webcam, dimensions variable, edition of 12, 1 AP. Courtesy bitforms gallery, New York. Photo: Antimodular Research

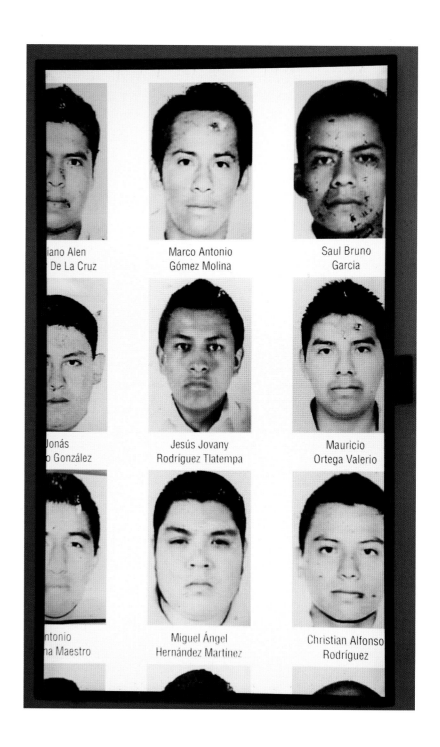

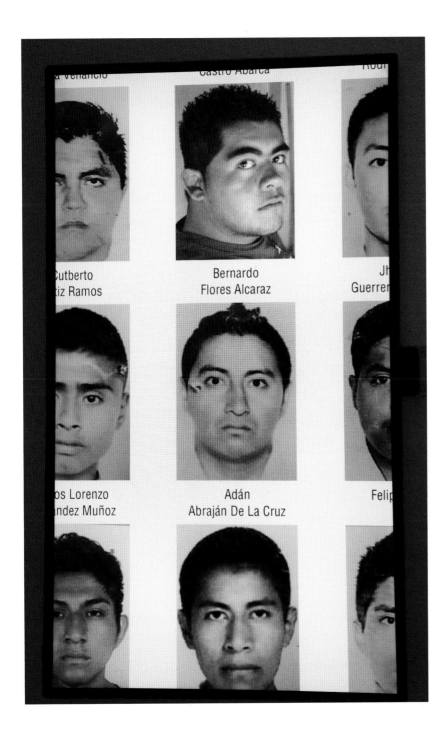

not as an artwork but as a campaign. Perhaps the most grueling moment came when a mother of one of the kids came and saw herself in the mirror and her son's image came on the screen. It gave her an 87 percent level of confidence that it was her. We were all in tears.

A media artist working at the intersection of architecture and performance art, **Rafael Lozano-Hemmer** *(Mexican Canadian, born 1967; lives and works in Montreal) creates platforms for public participation using robotics, custom software, projections, internet links, cell phones, sensors, LEDs, cameras, and tracking systems, often employing vanguard technologies. These "antimonuments" expand and challenge our idea of site specificity, creating relationship-specific work through connective interfaces. He was the first artist to represent Mexico at the Venice Biennale with an exhibition at the Palazzo Soranzo Van Axel in 2007. His public art has been commissioned for the activation of the Augusta Raurica Roman theater near Basel (2018), the preopening exhibition of the Guggenheim Abu Dhabi (2015), the Vancouver Winter Olympics (2010), Memorial 68 in Tlatelolco (2008), and millennium celebrations in Mexico City (1999). Recently, Lozano-Hemmer has been the subject of nine solo exhibitions worldwide, including a mid-career retrospective,* Rafael Lozano-Hemmer: Unstable Presence, *coproduced by the Musée d'art contemporain de Montréal and the San Francisco Museum of Modern Art (2021); a major show at the Hirshhorn Museum and Sculpture Garden in Washington, DC (2018), and the inaugural show at the Amorepacific Museum of Art in Seoul (2018).*

Interview with Lilly Lulay

CHRISTOPHER JONES
January 13, 2021
Conducted via Jitsi

Lilly Lulay, *Our Writing Tools Take Part in The Forming of Our Thoughts, A*, 2018, laser-cut inkjet print, 200 × 150 cm. Courtesy of the artist and Galerie Kuckei + Kuckei, Berlin

CHRISTOPHER JONES: I'd like to discuss what interests you and motivates your work. You initially studied photography, sculpture, and media sociology. What attracted you to photography initially? And how were you able to make connections between your sculptural practice and photography?

LILLY LULAY: What interested me, and what still interests me, about photography is the relation that it creates with reality—the connections it creates with something that is far away in space or time. I grew up in the 1990s, at the beginning of the digital era, and I remember all these discussions about the truth or lack of fidelity in digital images. That we cannot trust images anymore because digital images aren't physical *imprints* of reality. The beam of light doesn't touch the negative but a sensor *translates* this information into code, and so on. It's not the technique which decides if a photo is trustworthy or not but the social conventions and usage of images.

I grew up with tactile feedback from the physical world. That's what I like about working with photography in a sculptural way—that I can touch it and that I can create a physical experience with something. Photographs are always flat, no matter if they are on a screen or on a paper print. But every kind of photographic medium has a physical body: made out of paper, made out of diapositive material, or made out of a smartphone. And this body is very important. It decides how images are archived, how they circulate, how they are stored, and... how they can be used in a social setting.

CJ: Thinking about your interest in sculpture and the tactile qualities of photographs, is this a resistance to the idea of our digital reality? A reemphasis on the tactile? Is that something that we've lost in our era?

LL: Yeah, certainly. We are the best example, as we are doing this interview via screens. But also, think of architecture. I grew up in Frankfurt, a city destroyed by World War II. It has a lot of newer glass buildings with shiny surfaces, which reflect you like a screen. I think these flat surfaces made out of steel, glass, and so on, they are not only part of our digital life; they are part of our analog, urban life. If you think of office buildings or undergrounds, everything is made of smooth and shiny steel, glass, or plastic.

CJ: That's a really interesting comparison or metaphor: the idea of the glass, reflective surfaces of buildings in public spaces. There is a structure behind the facade that we don't see; we only see our reflections. And that reminds me of your interest in putting pressure on images in order to reveal the architectural structures behind them. Digital images are the reflective surfaces of social media platforms, for example. The unseen architecture is the algorithms and metadata that inform what we interact with or consume. These digital platforms are the new organizing principles for our social relations. We need to understand that architecture.

"These are the things that interest me about photography. Not so much the visual content on this flat surface but the social reality that develops in relation to photography—patterns of behavior that become visible through photography."

LL: Exactly! This is something I thought about when developing the series *Our Writing Tools Take Part in the Forming of Our Thoughts*. I realized that the layout of an app, the available icons, and the way that images are shown are like an architectural space that shapes our encounters with people online. Apps provide windows, walls, and furniture that structure our social interactions. Elements allow or prevent certain connections/interactions—the chat that pops up when you're on Facebook, or the features that move, which incite you to react.

It was a philosophy professor who made me think about that and who said that for hundreds of years, people were not surrounded by glass surfaces. They did not have mirrors at home. The only way to see themselves was in flat water and this was like, "oh wow, that's me." What does it mean for us to be all the time reflected, to be all the time visible?

CJ: Many artists are interested in how we interact with these surfaces—digital or photographic images—and the organizing structures or digital architecture around us, which we don't always see.
LL: Do you know "L'Act photographique" by Philippe Dubois? He says that as soon as a camera enters the room, the whole social configuration changes. People in front of the camera, and the person behind it, will adapt their behavior accordingly. They smile, pose, group together, or step out of the scene. I see a camera, a screened picture, an Instagram post as an "agent": something that acts upon us on an individual and on

a collective level. These are the things that interest me about photography. Not so much the visual content on this flat surface but the social reality that develops in relation to photography—patterns of behavior that become visible through photography.

CJ: I am intrigued by the way you cut into photographs. In your series *Amerika 2010*, you cut the sky from tourist photographs of American landscapes. And your recent work involves laser cutting. This appears to be a recurring strategy. Can you talk about this technique? Is it about reinserting the hand into image-making? In some images, it feels like a political act or gesture.
LL: It's different things. In the beginning, I worked a lot with found image material, so my gesture to cut out was a way to repeat what the photographer did: select one part of a given situation and cut it out.

My intervention—no matter if it's cutting out or painting over—is a means to refocus the viewer's attention and point to the fact that photographs are necessarily cutouts. Even if photographs show us something in a very detailed or realistic manner, they are always an abstraction: a flat, rectangular surface. They make us focus our attention on the scene depicted but do not tell us what happened before, after,

OPPOSITE
Lilly Lulay, *Our Writing Tools Take Part in The Forming of Our Thoughts, B*, 2018, laser-cut inkjet print, 87 × 116 cm. Courtesy of the artist and Galerie Kuckei + Kuckei, Berlin

or next to it. So photographs at the same time enlarge and restrict our field of perception. They are a window to and a layer between us and reality.

Because I work against that layer, my work is full of fragments, cutouts, superimpositions, details, and trompe l'oeil effects. And cutting into photographs is a critique of surfaces—a critique of a world where reality is intentionally obscured by visual appearances. Think of the idealized images on food packaging and what's really inside, on our visual culture online, or the fence of a construction site touting images of the luxury homes to come. In our culture, images are deliberately used to mask reality. I literally deconstruct photographs to shift attention from the visual surface of photographs to the material, technical, and social structures inside which they are embedded.

But my interest in cutting out and working with fragments is also informed by a reality that is more and more fragmented and multilayered. I think before the arrival of cell phones, the internet, and smartphones, my experience of time felt more contingent—less chopped into pieces.

Since I am researching the smartphone and the various algorithms that manage its visual contents, I also see my cutting

RIGHT
Lilly Lulay, *Our Writing Tools Take Part in The Forming of Our Thoughts, C*, 2018, laser-cut inkjet print, 60 × 80 cm. Courtesy of the artist and Galerie Kuckei + Kuckei, Berlin

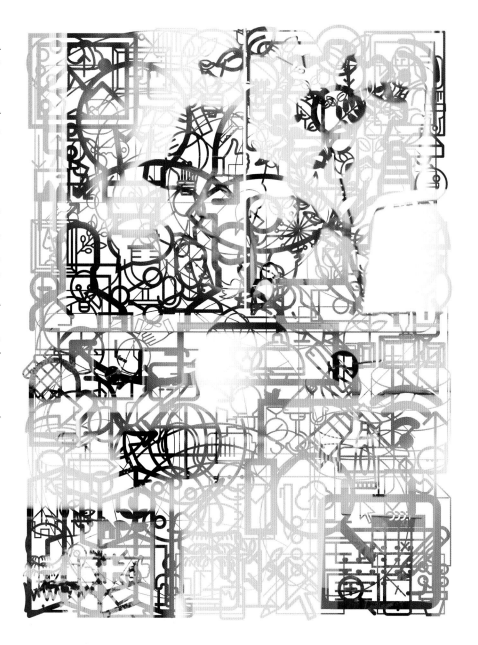

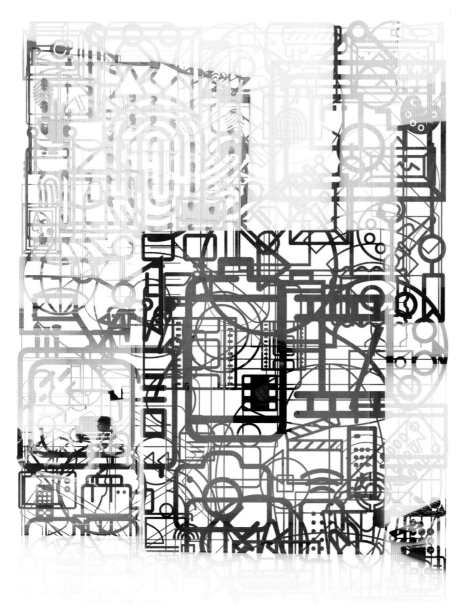

strategy—as you have named it—as a means to talk about algorithms. Algorithms choose what we get to see in our social media, news feeds, and online searches. They filter the masses of information and select certain contents to become visible to us, and not others. Algorithms highlight and obscure, just as I do with my work and just as even the most innocent photograph does.

CJ: Your cutting strategy changes a bit in your newer work, *Our Writing Tools Take Part in the Forming of Our Thoughts*. In earlier images, you're cutting out figures or the sky. But in *Our Writing Tools*, so much of the image is affected by the cutting. We see traces of conduits, almost like circuits. Could you talk about your strategy in this body of work?

LL: Now, as you say it, I think of another work of mine: *Liquid Portrait*. It's a sculpture of a friend of mine based on all her Facebook profile pictures. Here I use a similar technique in that the image is nothing but a frame and a little bit of content.

Our Writing Tools Take Part in the Forming of Our Thoughts—it's such a long title. The title is a quote from [Friedrich] Nietzsche, who used to write by hand, and then he

LEFT
Lilly Lulay, *Our Writing Tools Take Part in The Forming of Our Thoughts, D*, 2018, laser-cut inkjet print, 55 × 73 cm. Courtesy of the artist and Galerie Kuckei + Kuckei, Berlin

started writing with a typewriter. The story goes that this sentence was one of the first he wrote on his typewriter, to send to a friend in a letter. And it's close to Marshall McLuhan's famous "the medium is the message." Nietzsche realized that the tools he used to express his thoughts changed the way he thought.

Technical tools like a camera or a smartphone equally change our perception and behavior in what we express and what we internalize. And this series is probably different to the other cutouts because I'm not cutting out by hand. I'm using a laser, so everything is prepared beforehand and then realized by a machine.

The work is a series of pictures that I took inside the apartment of a friend of mine. This friend just received her first smartphone at the age of seventy, some months before, and she didn't really understand how to use it because she comes from a world where you have physical feedback. If you push a button, then you feel it. And so often I had to explain to her how to use her phone while actually being on the phone with her. I said, "OK, now we are in WhatsApp. If you want to send me an image, look at your screen on the bottom left. There is an icon that looks like a camera. If you click on it, the photo app will open and you can take a picture. Then use the icon that looks like a paper plane to send the image to me." I described where in the interface she would find an icon and what its meaning was. In that process, I realized that these icons are like a new language. It's a language more universal than

photography and it's something that all smartphone users around the globe have to learn in order to interact with their devices. I decided to treat the photos I had taken in my friend's apartment in a similar fashion to our "smartphone tutorials"—describing everything that's in each picture. I made an image description of what's inside her apartment, but I didn't use words. I used icons as a language. Then by superimposing these icons on different objects in the picture, I created a network structure, which is then cut out by laser.

Again, the initial image, the visual content, is not that important to me. And therefore it doesn't have to be visible that much. What was important to me was to think about how photographs are exhibited inside someone's living space or in the visual setting of an app, and how digital and analog architectures shape our social interactions.

Some works in the series are displayed ninety degrees to the wall, so that you can look at them from both sides. There is the colored side that confronts you with an overload of information and a back side, in which the information is reduced and where thus the icons and even the initial content of the photograph become much more visible. And if you light the work in the right way, you even have a third version of the same image or "data set." You have the front side, you have the back side, and then you have the shadow on the wall. So it's also about this duplication of information. I like that because, for me, the shadow is

also an allegory for all the things that happen in the background but which we don't really recognize. These shadows that we leave behind or these traces that we leave behind online and—

CJ: Is that our metadata?
LL: Yes, metadata. You can see the shadows as metadata that can be visible if you turn on the lights in the right way.

CJ: Your new work and research increasingly focuses on AI and the coded logic that controls the flow of images on social media and internet searches. Your newest project, *Lesson I: The Algorithmic Gaze*, works as a mask or a stencil to blot out certain parts of your image, while highlighting others. What have you learned about AI and algorithms and how has it inflected your thinking?
LL: I'm still digesting because there's so much to read and to learn. I think I became interested in the question of "What is artificial intelligence?" when I worked on *Digital Dust*, a series of self-portraits based on my Google Photos account. There I realized how good Google algorithms are at recognizing content. But of course they only have a limited number of things that they can recognize.

OPPOSITE
Lilly Lulay, *Unser Brautstrauß 22.12.1975/Our Bridal Bouquet 22.12.1975*, from *Lesson I: The Algorithmic Gaze*, 2020/21, scanned found photo, inkjet print on Hahnemühle Photo Rag Baryta, laser-cut wood plate, blackboard paint, and pen. Courtesy of the artist and Galerie Kuckei + Kuckei, Berlin. Photograph: Thomas Bruns

Our consumption of images on social media is mitigated by algorithms, or AI, that determine which images should appear first, who gets to see which images and why, and why someone gets more views than someone else does, and so on. But it's super complex. Those who build AI systems, for example for image recognition, cannot control the output. There are many people involved. It's not just someone who writes the code but also people who put together a data set for training and people who label these millions of images in a data set. There are many people involved and there is bias at work in every step. So AI is anything but neutral. It's based on mathematics and on statistics but that doesn't mean the outcome is objective. AI is biased in what it is able to perceive, but really good at picking images that provide a good feeling, where people are smiling and so on.

We have so many images today that we need these algorithms to help us find them. We have to rely on algorithms. And we have to trust them, even if we probably cannot. It's like a self-fulfilling prophecy because we have a phone which has seemingly unlimited possibilities for storing images. If it's full, we use a cloud service which is free, where we can store all our images. Then we produce even more images that we never have to select or delete. In the end, we are dependent on the platform that helps us to manage this overload of images. This again illustrates how new possibilities offered by technology lead us to change our behavior. Since the beginning of photography, there is this question: What can a photographer do with a camera and what does the camera do to the photographer?

CJ: Our experiences with digital image culture, regulated by AI and algorithms, point to a dystopian culture of control. We are generating vast amounts of image-based information and constantly uploading it to the cloud, where it becomes the raw material for tech companies like Facebook or Google to monetize. We are the product now—our experiences.

LL: I found it so concerning when I realized that I allowed Google to analyze the content of all of my images… I didn't read their terms and conditions. They know all the places where these images have been shot, all the places I have been, because this information is in my pictures' metadata. Through my photos, I unconsciously told Google where I was, when, with whom, and what I did and photographed. I haven't worked with it yet, but there's a visualization, a map of all the places that you've visited. And if you use Google Maps and Google Photos, it will integrate all your images onto this map. It visualizes the amount of information that we share every day with this company. But it's just one little piece of what they know about us, because we also have Google Search, Gmail, Maps, Docs, and YouTube—all this concrete information and metadata about our lives that we're constantly sharing with these companies. But, as [Donald] Trump's election or rather the Facebook–Cambridge Analytica scandal showed us, this information can be used against us, or to influence us in a very subtle manner.

I know many people who say, "I don't really like Instagram, yeah, I always have to force myself to post something." But still we do it. And we are on Facebook, LinkedIn, and so on. We do it because there is this social pressure or this convenience that comes with technology.

Today, there is just soft power. Instead of forbidding us to do something, they just seduce us to do something. We're living in a world full of buttons that say "accept terms and conditions" or "I like it."

*Through her work, **Lilly Lulay** (German, born 1985) examines photography as a cultural tool that forms an integral part of daily life. As a response to the overproduction of images today, Lulay treats her own and other people's photographs as "raw material." Through a variety of techniques that range from laser cutting to embroidery, and from installation to collage, Lulay turns photographs into palpable objects that provoke us to consider the influence that photographic media have on social behavior and the mechanisms of our individual and collective perception. Lulay received a Stiftung Kunstfonds grant in 2019 and was selected for the FOAM Talent program in 2018. Her work is in numerous collections, including the George Eastman Museum, Rochester, and Deutsche Börse Photography Foundation, Frankfurt. She is a graduate of the Hochschule für Gestaltung Offenbach am Main, Germany.*

OPPOSITE
Lilly Lulay, *9 SEPT 2017* (detail), from *Digital Dust*, 2018, inkjet print on double-sided fabric and cement base, 50 × 297 cm. Courtesy of the artist and Galerie Kuckei + Kuckei, Berlin

Interview with Trevor Paglen

CHRISTOPHER JONES

January 6, 2021
Conducted via Zoom

CHRISTOPHER JONES: *Trevor Paglen: Opposing Geometries* is currently on at the Carnegie Museum of Art in Pittsburgh. But at the moment, you are working from Australia as the pandemic continues. I am sure that we will all spend many years sorting out the social and cultural impacts of COVID-19, but I'm wondering if this past year has led you to any revelations or broader takeaways regarding your thinking or how you approach making art.

TREVOR PAGLEN: A lot. There are things to talk about—technology and AI and machine learning and data collection—all in relation to the fact that we're living online in an even more extreme way than before. However, I think for me the takeaway is about how quickly meanings can change. We all have relationships to our everyday environments, to different kinds of images that we see in our lives, to gestures that we make. For me the sustained thread is thinking about how frangible those relationships among objects, gestures, and images and their meanings are.

In the early days of the pandemic, the meaning of an airplane in the sky changed very quickly, or the meaning of what it meant to type your PIN into a credit card reader. That has built out for me into a much larger series of questions about allegory. I think those of us who have studied visual studies start thinking about images as representational. This is an image of an apple: it refers to an apple that may or may not be in the world. The pandemic has made me question that to a very, very deep extent. I now consider that representational thinking about images—i.e., this data or this image corresponds to something in the world—as being almost entirely arbitrary.

In terms of thinking about metadata, this has huge implications. The concept of metadata is that some information is partly internal and partly external to some kind of phenomena, but that data is classificatory. We imagine that the metadata has some kind of truth-value that situates a piece of information. This year has shown me how unstable that implied relationship is.

CJ: In the new context of the pandemic, the connotations or secondary meanings of common images have radically changed. If you watch a movie made before 2020 with a scene of people gathering maskless in a social setting, that image now signifies the danger of contagion and sickness. Common images have a different valence as meanings have reshuffled on a deep level. However, it sounds like you're fundamentally reconsidering how we think about this category of representational images.

TP: There's a starting paradigm to think about images. Then you debunk it, you show how it's unstable, you critique it, and you play with it. But what if you didn't start with that at all? What if your starting assumption was that images are allegorical instead of representational? Or you started with the idea that images are operational? They always do something, rather than represent something. Do you come up with a different philosophy of images? You do, obviously. But what happens if that kind of representationalist paradigm becomes a special case of images?

"I think about images as being a kind of vocabulary that helps us make sense of the world."

CJ: Several years ago, you photographed dark sites that were part of a vast military intelligence surveillance system developed by the United States and its allies after 9/11. Through your photographs, you grant the viewer access to look at these sites and the infrastructure of surveillance, such as a view of the National Security Agency (NSA) from overhead. Yet, these structures are opaque. We are reminded of the famous line from Bertolt Brecht that a mere photograph of the Krupp works factory doesn't tell us anything about the armaments being manufactured within it. We wouldn't know what was going on in the NSA building if Edward Snowden hadn't leaked documents on the agency's activities. Your recent work has dealt with machine vision and operational images. Is this a change in your relationship to images, away from a representational mode?

TP: They're all grounded in the same thing. I think about images as being a kind of vocabulary that helps us make sense of the world. We have words like "apple" or "orange" or "angel" or "chimpanzee." That doesn't mean that those things actually exist in the world. It just means that those are tools that we can use to communicate with one another. All of those tools can be crude. A word like wave, that's an incredibly crude word; it means a billion different things. But it's useful to us. We just want to make sure that we don't fall in love with the tools that we make and imagine that they accurately describe the world.

I think images can do the same thing. I don't think that a picture of an NSA building really tells you anything about what's going on in the NSA. Far from it. But it can be part of a visual vocabulary that you use to try to have a conversation about something in a broader sense.

The same thing is true of working with algorithmic systems or computer vision systems. You can work with them in different ways or in ways that they were not meant to be worked with in order to have a larger critical conversation about those technologies in particular or the paradigms that they come out of.

CJ: Your work has been concerned with machine vision and image-interpreting AI, as well as its social implications. As you have commented, "most of the images in the world are made by machines for other machines, and humans aren't even in the loop." In the past few years, you've worked to put us "in the loop" and to see some of these images. In your series *Adversarially Evolved Hallucination* (2017), you work with a GAN (generative adversarial network) in which you train artificial intelligence algorithms to create new images based on sets of pictures that you've classified. What made you interested in creating images in this way?

OPPOSITE
Trevor Paglen, *Rainbow (Corpus: Omens and Portents)*, from *Adversarially Evolved Hallucination*, 2017, dye sublimation metal print, 54.6 × 68.3 cm. Courtesy of the artist and Metro Pictures, New York

TREVOR PAGLEN

Trevor Paglen, *Vampire (Corpus: Monsters of Capitalism)*, from *Adversarially Evolved Hallucination*, 2017, dye sublimation metal print, 152.4 × 121.9 cm. Courtesy of the artist and Metro Pictures, New York

Trevor Paglen, *A Man (Corpus: The Humans)*, from *Adversarially Evolved Hallucination*, 2017, dye sublimation metal print, 121.9 × 152.4 cm, The John and Mable Ringling Museum of Art, museum purchase with funds provided by Dr. Sarah H. and Dr. George Pappas, 2021.26. Courtesy of the artist and Metro Pictures, New York

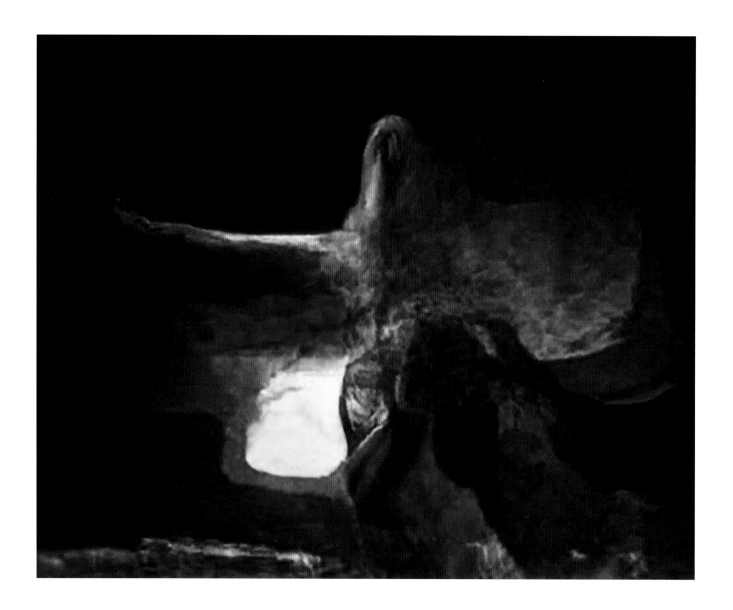

TP: GANs had recently been invented when we made those images, and now they're very commonplace. They're making deepfakes now, when you see people who do not exist. Those are more sophisticated versions of these GANs.

To me those images are about the data sets and about how you organize taxonomies. What kinds of meanings are generated through different systems? It goes back to these questions about allegory and representationalism. They were reactions to computer vision systems that had one-to-one relationships between images and meanings.

Many of the taxonomies that we use to create knowledge are very elliptical. Think about psychoanalysis, the interpretation of dreams, for example. In Freudian psychoanalysis, nothing in a dream actually means what it is. You interpret it. It has secondary and tertiary meanings and you generate taxonomies based on those. A system of symbols is similar. If you look at allegorical traditions, there are huge tomes of texts that describe the meaning of an olive branch in a particular context versus another one. So much of the way that we interpret images around us

is based on those meta texts or taxonomies. That is something that is completely elided by technical approaches to vision or interpretation.

That project involved making my own training sets, but in ways that would be completely illogical within a computer vision or machine learning framework. And that was the point. Can you make these kinds of irrational data sets? Sure, you can. They're not useful to the science of computer vision but they're meant to point out some of the shaky premises that the field of computer vision is built upon.

CJ: You demonstrate those shaky premises in your work *Machine Readable Hito* (2017). In it, you've taken hundreds of portraits of artist and media theoretician Hito Steyerl making different expressions and then submitted them for analysis to various facial recognition algorithms. These AI were created to determine gender, emotion, and other characteristics. We're presented with a grid of Hito images with percentage possibilities of gender and other features. The encounter between AI and human feels quite absurd, like a parody.

TP: That's intentional. *Machine Readable Hito* is meant to be absurd. It's preposterous. But the algorithmic systems that are used in that piece are built into commercial products all over the place. You just don't see them as a user. I am trying to use those tools to point out their limitations. Or to point out basic stuff, like the fact that often in a computer science or engineering context, there are claims to objectivity or claims to "it's just math, it's value free" that are not true in any way.

We can take this back to the computer scientists and say, "This is bullshit." That conversation is starting to happen now and I'm happy to have played a small part in that. When you look at current debates happening around AI and computer vision, you increasingly see people of the younger generation asking questions like, "Oh, can you really infer gender from looking at an image of somebody? Does affective computing [analyzing emotions] really tell you anything?" Those questions came from people in the arts and humanities, and fortunately there are some people within technical disciplines who are taking those questions seriously. That's a recent development.

CJ: You explore facial recognition technology in other works, for example *"Weil" (Even the Dead Are Not Safe) Eigenface* (2017), is part of a series of portraits of twentieth-century philosophers and writers. In each, we see only the "eigenface" or the minimal visual information an AI needs to identify a human face. The tone here is ominous.

TP: The eigenfaces are more serious. For me, they're a way to think through what happens to time, as well as what happens to politics in a world where everything is machine-readable and technologies of identification, like facial recognition, are ubiquitous. Most of the figures in the *Eigenface* series are people who I wonder would have existed if facial recognition were available at the time in which they were working.

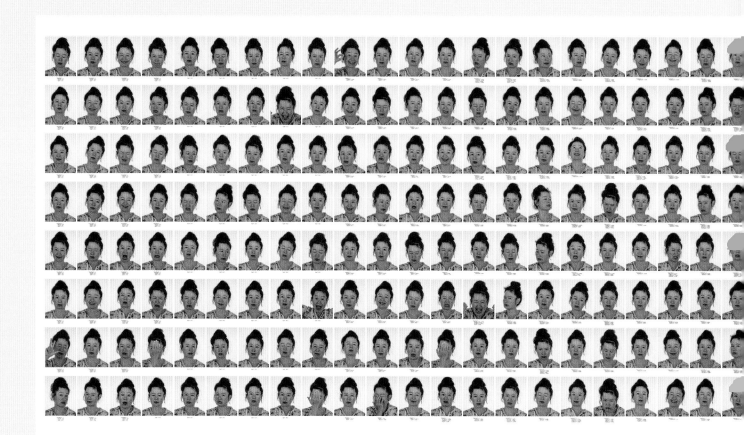

ABOVE

Trevor Paglen, *Machine Readable Hito*, 2017,
adhesive wall material, 490.2 × 140 cm.
Courtesy of the artist and Metro Pictures,
New York

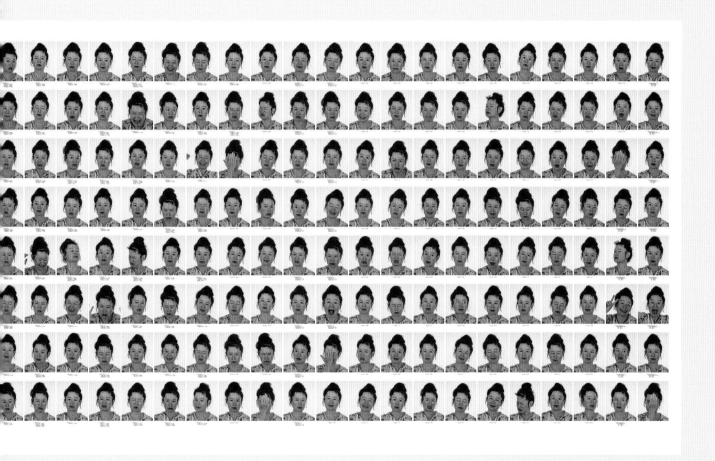

CJ: Frantz Fanon is another portrait from that series. Today we value Fanon as an anti-colonialist writer and activist, but if there had been ubiquitous surveillance and facial recognition software on the streets...

TP: ...of colonial Algeria, Fanon wouldn't exist as we know him.

CJ: I see the eigenfaces as deriving from a logic that originates with Francis Galton, the nineteenth-century British eugenicist who used photography to create composite images of criminal "types" compiled from portraits of convicts. As a society, we still seem to be taken with this notion that optical realism is our direct access to truth or knowledge, that we can access essence or character through facial features. Physiognomy has been refuted as a pseudoscience, yet we are programming AI to read facial features. How do we put an end to these reductivist practices once and for all?

TP: That's a very good question. There is something so appealing about vision in particular because it can be quantified in different ways. Intuitively, we want there to be a relationship between visuality and truth, even though we know that's not true. But again, I think it comes down to politics and power and economy.

The idea, for example, of an insurance company or an auto or television manufacturer having a camera that can measure your emotional content while you're engaging with its tools is so attractive that, even if it doesn't work, there's still a massive incentive to want it to work enough that you almost will it into existence. I think similar things are true of policing.

CJ: So much AI training or algorithm creation that is used to interpret images is based on reading their metadata—correct?

TP: Some just look at Exif data or other kinds of technical metadata, but it gets blurry and I don't understand the lines between these definitions. If you create a training set of apples and oranges, you can say that the metadata of that training set are the labels that the people who made the data set applied to it. In other words, they said, "Here's a thousand pictures of an apple. Here's a thousand pictures of an orange. Here's a thousand pictures of a banana." Those images have been contextualized in a particular way in order to teach the machine learning systems, and the particularities of those contextualizations are a form of politics. At a more fundamental level, the idea is that you can say, "This thing means this over here." That chain of meaning is true and universal, and that in and of itself is a very political thing. In other words, you can say, "This is one picture of a banana and this is also a picture of a banana," and there is something that unites those two things in a way that you can derive a greater truth from.

Those classifications are not done in a vacuum. In the case of the military, those classifications are designed to enhance military power. In the case of a corporation, those classifications are designed to extract value from the things that they're classifying. These forms of metadata and the forms of the creation and interpretation of metadata are motivated by either economic policing or military power, so the politics are built into it from the start.

CJ: For this exhibition, we are using the idea of metadata in an expanded sense to explore the information that travels with or coordinates images beyond what is depicted. This can include inscriptions on the backs of old photographs or the information in digital image files. Whenever we interact with or send images online, we unwittingly create more metadata. Would you speak to the idea of metadata in your work?

TP: More and more, these distinctions don't make sense—what's data versus what's metadata versus what's your imagination. I get caught up in the definitions here because I don't think that they're always precise. I think the photograph example that you gave is very relevant. If you have a photograph, you can think about that as data. What is the information that is contextualized in that photograph? For example, there may be a caption, a time stamp, a location, or the name of a person—extra information that contextualizes the thing that you're looking at. Who gets to decide what that metadata is? What kinds of inferences are made from that data? How does that metadata contextualize an image? And, therefore, what kinds of truth claims does it create a framework for?

CJ: I read a quote by you in which you assert, "In a very real way, our rights and freedoms will be modulated by our metadata signatures."

TP: When I think about metadata, I instantly think about signature drone strikes as the paradigm for the weaponization of metadata. Signature drone strikes are the phenomena that came into full formation in the Obama administration. They would target people for assassination based on things like if they were using a particular cell phone, or if they were in a particular place in the vicinity of other people. The idea is to target people for assassination based on a metadata signature that fits a profile.

I think about that as a paradigm of the weaponization or operationalization of metadata because we see so many aspects of our everyday life in which our de facto rights and liberties are modulated by metadata signatures. For example, in the auto insurance industry, it is clear that what they want in the very near future is a scenario in which you wake up, you say that you're going to work, and instead of an insurance policy, you see a display on your phone. It will state, "You should take this route to work," and it'll measure you. If you go the way that they suggest and if you travel at the speed that they suggest, then your insurance policy will go down. If you deviate from those recommendations, it will go up. You'll see similar aspects of surveillance in many health insurance plans.

This new paradigm of classification via metadata and its very real immediate consequences will become more and more a part of the texture of our everyday lives.

CJ: Your methodology is grounded in experimental geography, an interdisciplinary approach to critically interrogating the production of space. I am oversimplifying, but experimental geography helps us to understand the feedback loop between how the environment shapes human activity and how human activity shapes the environment. As you have described it, it is a practice directed toward producing new spaces that may be more democratic and freer.

TP: I'm weirdly not so cynical about art. I think about it in a basic way. The point of museums is going and looking at images; the point is education. That's pretty good. There aren't a lot of places like that. Sure, there's an industry and, sure, there's money laundering. There's all kinds of crap going on in the art world, but at the same time there is a pretty substantial proportion of people trying to think through how to see the world around us and how to think about questions that are relevant to society. I feel like those kinds of places are rare and I don't want to throw the baby out with the bathwater.

I don't think art is going to save the world. I don't think that anybody's ever made an artwork that everyone thinks is "Mon Dieu!" revolutionary artwork. That's not how it works. I don't have those expectations of art and I think one can easily have too much faith in art. But I do think that you cannot reduce our field to a system of exchange. That is part of what we do, but it's not the point of what we do—unlike an Amazon, a Google, or a Ford.

*Among the chief concerns of **Trevor Paglen** (American, born 1974; lives and works in Berlin) are learning how to see the historical moment we live in and developing the means to advance alternative futures. His wide-ranging approach documents invisible infrastructures, from corporate and government sites to networks known through technologies of nonhuman machine vision. His practice spans image-making, sculpture, investigative journalism, writing, engineering, and numerous other disciplines. Paglen's work has appeared internationally at biennials and in numerous major exhibitions held at the Metropolitan Museum of Art, New York; Tate Modern, London; and others. He has also been featured in solo shows, including a mid-career survey exhibition in 2018,* Trevor Paglen: Sites Unseen, *held at the Smithsonian American Art Museum in Washington, DC. He has received numerous awards, including a MacArthur Fellowship (2017), Deutsche Börse Photography Foundation Prize (2016), and Electronic Frontier Foundation Pioneer Award (2014) for his contributions to countersurveillance. His authored publications include* The Last Pictures *(2012),* Blank Spots on the Map: The Dark Geography of the Pentagon's Secret World *(2009), and* I Could Tell You but Then You Would Have to Be Destroyed by Me *(2007). Phaidon published his first monograph in 2018. He holds a PhD from the University of California, Berkeley, and an MFA from the School of the Art Institute of Chicago.*

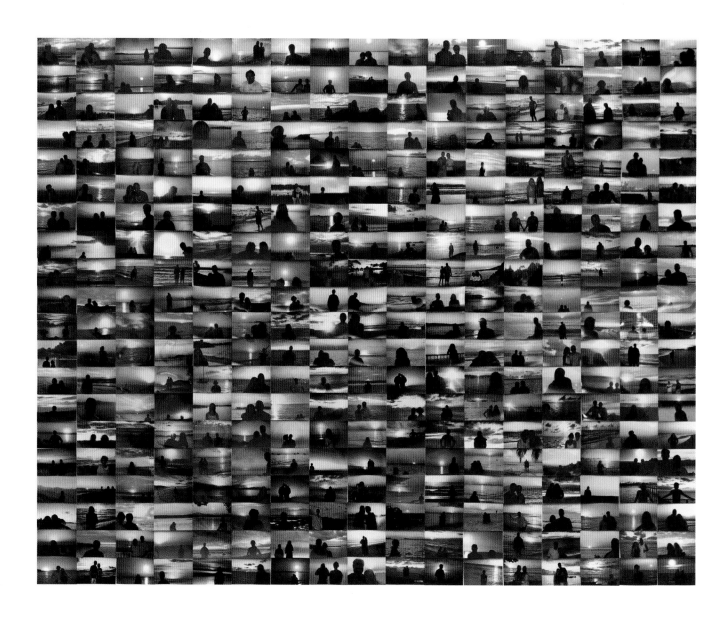

Interview with Penelope Umbrico

CHRISTOPHER JONES

January 18, 2021

Conducted via Zoom

CHRISTOPHER JONES: Your art is almost entirely focused on working with appropriated images culled from catalogs and the internet. Why is working with these images so appealing to you?

PENELOPE UMBRICO: I remember as a kid going to the five-and-dime store that was close to my house. It was called Kresge's. I remember wandering through the aisles there and understanding something about the world by what was for sale. There were all of these sections, like for bras and a pet section with all these pets for sale like hamsters and guppies. And there was a knick-knacks section with little china cats. It was like going to a museum. I'm still doing that in my work as I look through images. It's a way of discovering something about other people and the world. I'm not that interested in showing the world what *I* see. I'm much more interested in what the world is seeing and then showing that to the world.

CJ: Thinking about the way stores display objects and products—that is a form of an image, isn't it? Arranging visual information in space in an orderly way. The department store display also arranges these objects as commodities into a signifying system. They are arranged into a relationship of equivalence in terms of their exchange value. That visually communicates information to us about the logic of the world, of which we are a part.

PU: I had not really talked about this much before, but you're absolutely right. And the idea of typology is there, too. My experience of the department store was that the objects were arranged in typologies, usually within grids, and within them was a clear hierarchy in terms of where things are placed within specific categories and departments. Thinking about this, what I find fascinating is how the formal composition of those spaces is like my work now. I arrange things into a typology that has something to do with value and exchange.

CJ: The way you collect images to create typologies and grid-like installations is another sort of realism, another way of representing or documenting the world—isn't it?

PU: I don't think it's much different than documentary photography. I'm documenting what people document. To me, that is more interesting. Of course, I'm making choices about what those things are. I'm also interested in phenomena. I think it goes back to that first discovery of the world through the store. I was discovering phenomenon like a *thing*. It probably has a lot to do with commerce: so many people want this thing. Why do they want it? What is its value there?

Images are a great way to access that. It is easier to collect images of objects that people desire than it is to collect the objects. It would be impossible to enter each person's home and ask them what they have invested in or like enough to not throw away, but do not find useful anymore. On eBay, that's exactly what you see. There is something about *exchange* there—the idea of where the value of something lies.

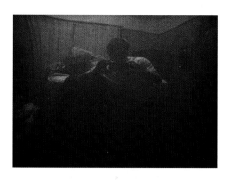

CJ: I can see that in one of your earlier projects, *From Catalogs* (1996–2000). You have rephotographed close-up details of objects from consumer catalogs that you received in the mail. Then you arrange your photographs into grids on the gallery wall. These were all catalogs like Crate and Barrel or Pottery Barn that address a certain lifestyle and identity. After this work, you pivoted to online sites like eBay or Craigslist for your source material. What led to that shift for you?

PU: That work began by thinking about desire—how it's constructed within a capitalist consumer culture, and the currency of images in that context. It has always been interesting for me to think about what an image connotes—what I can find that is not on the surface.

A major influence for me was a 1973 book by Wilson Bryan Key, *Subliminal Seduction*. It looked at advertising images to find hidden messages. Most had to do with sex. You know, lipstick in the form of a penis, or the letters *S E X* hidden in ice cubes. Nevertheless, there was something about that idea that resonated with me when I was young—the idea that every image could have something hidden in it.

The shift in my work from more corporate spaces to consumer-to-consumer spaces was possible with the onset of Web 2.0—the participatory web. Before people could post their own images on consumer-to-consumer market sites, I was reliant on corporate marketing as a source for subjects.

Both reveal cultural phenomena that point away from the intended meaning in the photographs, but images people share on consumer-to-consumer sites are far more interesting. Flickr, Craigslist, and eBay give me access to the kind of pictures that you and I and our mothers, aunts, uncles, and grandmothers take. You can really get close to strange underlying phenomena looking at non-photographers' pictures of things they value enough to sell, but not enough to keep.

CJ: Some of the images that you have gleaned from Craigslist would be considered throwaway images—digital snapshots illustrating things for sale like remote controls, broken LCD screens, and castaway things. For your series *TVs from Craigslist* (2008 to present), you appropriate the images of the screens people are selling as subject matter for your photographs. What was your interest in these lowly forms of images?

PU: An aspect of *TVs from Craigslist* was about exchange. For each image in an installation of that project, I only made two prints: one for exhibition and the other to sell on Craigslist for the price of the TV the image was sourced from. If you're searching for a TV to buy, you might come across my print instead. It may be an eleven by fourteen-inch print for sale for only twelve dollars. If you're looking for a work of art, it's a great deal. If you're looking for a TV, it's not. I was interested in that exchange or that collision of these two markets—fine art and consumer.

"For me, there are a lot of messages revealed in these images. They are revealing the mechanics of the technology that we're subject to, and the tyranny of that technology."

A predominant idea around digital media is that photography has become democratized—everyone can take a photograph. But in some ways, I think that it has become more tyrannical because we are all subject to the technologies that are available to us, and those technologies tend to dictate how we take photographs. I wonder if most people taking and sharing images understand the implications of their images within a larger context. Collectively, they reveal the mechanics of the technology that we're subject to, and the tyranny of that technology. In *TVs from Craigslist*, it is possible to track the changing technology of both the screen and the camera. The behavior of camera flashes and reflections on the varying surfaces of the screen has shifted dramatically over the twelve years I have been collecting these images. Moreover, as camera technology becomes more sophisticated, flashes are less necessary and the thumbnail images on Craigslist have become larger, revealing greater detail.

The thing that drove that body of work was the underlying humanity that remains on the surface of the TV as a reflection. However, there is a slightly voyeuristic element to it, too. I'm traveling around America in the bedrooms of people who are selling their TVs. They're letting me in by posting these images of their bedrooms with the TV in it that they're selling. Sometimes they are so intimate; you see their messes, their unmade beds, and the sellers standing there, in various states of undress, sometimes even naked.

It's a little sad in a way. These TVs were once the center of the seller's home, and now, in what are probably the only pictures of these TVs, are the little ghostly figures of the owners who don't want them anymore, forever reflected there. They have become like memento mori pictures to me.

CJ: You've realized several projects that source images from Flickr, the image-sharing community that began in 2004 as one of the first platforms to store and share images on the internet. What led you to Flickr as a source to mine images and how did you arrive at the sunsets as subject matter?

PU: It was at that moment when people started sharing images and I was moving from thinking about consumer images to personal images. Being interested in the phenomena and the practices that we have around image-making, I wanted to determine the most photographed subject. I started it when Flickr began in 2004, but it took me a few years to realize the project. I was searching Flickr and things like "kitten," "baby," and "me" came up, but "sunset" was the most photographed and tagged image.

We only have one sun, but that there were fifty-four thousand images tagged "sunset" blew me away. It was fascinating, so I collected them all. I downloaded as many as I could that had an image of the sun in them that I could isolate. I was collecting them for a couple of years before I realized, in 2006, that it was the singularity of the sun and multiplicity of it on Flickr that was so fascinating. I cropped all of these images of the sun and assembled the first piece in 2006.

CJ: It reveals the social act of photographing, the ritual aspect. We certainly don't need all of these images of the sun. They don't provide new information about the sun.

PU: We all take pictures of the sunset, and the kind of sunset that we want is a very scripted image. Everyone wants the same sunset where the sun is just above the horizon—it's beautiful and warm. What is fascinating to me is that ritual, that we all do it, but also that people want to claim the image as their own. To me, that claim denies the beautiful, collective ritual that we're all participating in. One of the things that has driven this work is to parse out what that claim means. As soon as you share the image, it's in the company of fifty-four thousand or, now in 2021, forty-eight million other images that look almost exactly the same. Isn't that something so beautiful? What is behind saying, "It's my unique image because I took the photograph"?

In assembling the *Sunset* installations in my studio, I realized there was something impactful about having them as a collection of singular prints. Each photograph has an individuality, but within the collection, they become one big whole. There is something so experiential about it. When you experience the installation as it fills your field of vision, it makes you feel immersed in that collective ritual—this experience of photographing the sunset. But as we've all thought about our individual experience of that moment as unique, it can feel humiliating on a certain level, to view it as a collective phenomenon.

CJ: That experience is the most intense in your ongoing *Sunset Portraits from Sunset Pictures on Flickr* (2010 to present). That feeling of the loss of our individuality, our unique subjectivity.

PU: The *Sunset Portraits* taught me something about the effectiveness of an artwork in that you can stand in front of that installation and not know anything about the work. I don't have to tell the viewer anything. The next time you're standing on the beach at sunset and someone is taking your picture, you'll understand inherently that this is a collective action that millions of people do. But the camera in these pictures is exposing for the sun, not the people, so the people have all but disappeared. They are silhouettes.

Making this work was melancholic in a way. All of these images that people take and share, that say, "Here I am on earth, standing here in front of the sunset." It's like an insistence on presence in the face of feeling absent or disappearing. And there are so many of these images. We have become atomized. There are images of us, all of us, everywhere. We have no control over them. There's an element of psychological anxiety in this insistence on presence through a photograph. Perhaps they are a manifestation of this set of conditions.

"We all take pictures of the sunset … What is fascinating to me is that ritual, but also that people want to claim the image as their own."

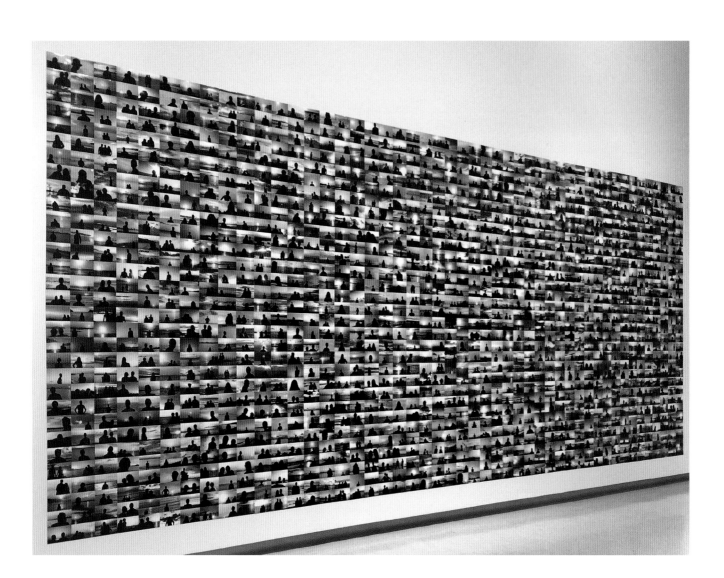

The installations speak to the ubiquity of this phenomenon, the ritual of it, and the multiplicity of its form, but it's not just the fact that we feel as though we're among millions of other people doing the same thing. There's also the fact that this simultaneous disappearing and insisting on our presence in time is taking place through the technology. We are both appearing and disappearing because of the technology.

CJ: In the *Sunset Portraits*, **the technology has failed us. The figures are silhouettes because the camera is compensating for the sun behind the figures in the exposure.**
PU: Exactly, and oddly, these images are disappearing. Finding pictures for the *Sunset Portraits from Sunset Pictures on Flickr* is harder to do now because camera technology is getting smarter. With facial recognition technology, the camera exposes for the face. Recently when I looked, I found only ten more to add to the group.

There is an interesting connection between *TVs from Craigslist* and *Sunset Portraits*. They present an opposition. The people taking pictures of themselves at sunset are insisting on presence, on their authorship, on a certain level. But in those pictures, they are disappearing. In *TVs from Craigslist*, those people don't care about those photographs. They're garbage photographs—just to sell the TV. And yet, in those pictures we really see the individual. We see the subject in the most intimate way. I love that opposition.

In *TVs from Craigslist*, as camera technology has improved, I am finding so much more detail in the reflections. I don't think that people are aware that there is so much revealed in these reflections.

CJ: In these projects sourced from Flickr images, have you received any pushback from the online community about your appropriation of others' images? If so, what have you learned from this?
PU: My other project working from Flickr, using images of moons, *Everyone's Photos Any License*, began because I was curious about why people on Flickr make their photographs of the moon "rights reserved" when it's easy to get high-resolution images of the moon from the internet, from NASA for example, for free. All images of the moon are going to look pretty much the same (since the moon always faces us the same way).

I messaged 684 people through Flickr asking for permission to use their image in a show of full moons from Flickr. I offered them a licensing agreement in which I would give them part of my commission, based on how many images were in the installation, if I sold the work. I thought it was fair and I received a lot of responses. One person agreed to the permission, but then, after looking at my website, messaged me later very upset. He saw a project I had done as a response to a question about the ownership of the circle of the sun, and he complained about me using other people's photographs that have licenses on Flickr. His reasoning was that they spent a lot of money on camera equipment and should be able to sell their work. I do not have any problem with anyone selling their work, but his response taught me what this project was about. There is a colonialist attitude: you have the money, you get sovereignty. In this case, you get the moon.

I have since started a project working with Google Moon. It's like Google Earth but with the surface of the moon. It's great: you can see the surface of the moon in a way you wouldn't otherwise be able to. But it's also territorializing the moon. I have such mixed feelings about it—I love the technology but I hate what it's doing at the same time. I think that tension is what allows me to keep making work.

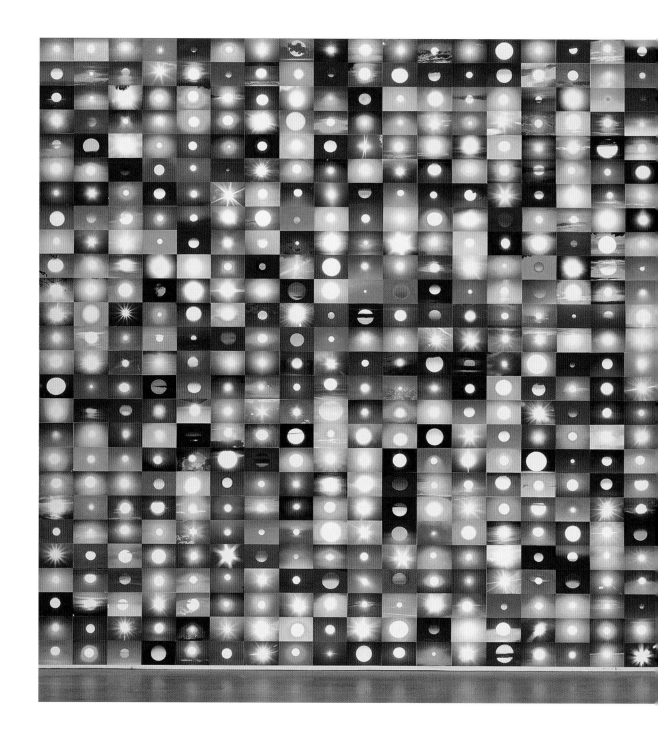

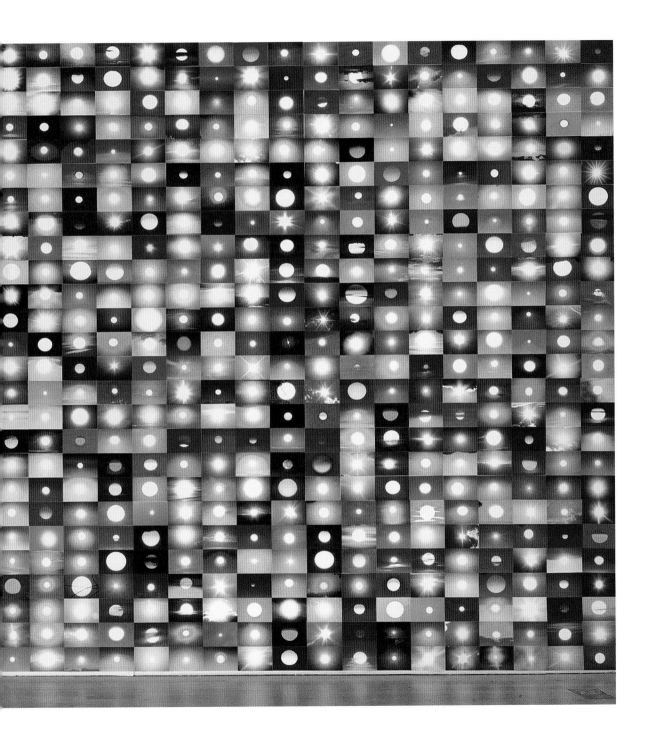

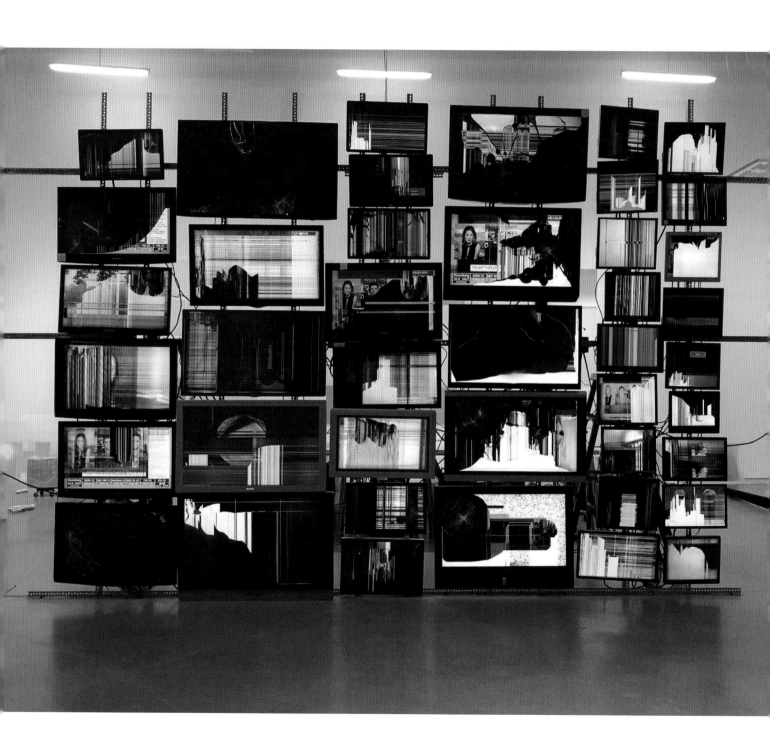

CJ: Vilém Flusser used the term "black box" to describe any apparatus that mechanizes and automates some, or even all, of our thinking in ways that are technically obscure to us. There is another current in your artistic practice that involves creating sculptural work and prints from the "black boxes" of our lives: LCDs, laptops, tablets, and other screens. What motivates that aspect of your work?

PU: Flusser's essay and philosophy is really about working with the "black box" and knowing that there's no way we can understand the technology behind the devices that we're using. I think he was calling on us to become active users rather than passively using technology in ways we're told to, even if we can't truly understand or see the mechanics.

What's fascinating to me about the screen is we actually tend to treat it or think of it as if it were invisible. We're never aware of the screen's physicality. We're always looking through the screen at the information it displays. The broken screen articulates its liquid messiness. It's no longer slick; it's no longer invisible. It's physical and uncontained and uncontrollable.

I was invited to create an installation called *Monument* at BRIC Arts Media in Brooklyn in 2018. We set up a temporary e-waste intake center where people could bring their old screens and devices. We set up a table behind a wall of semi-working screens streaming cable news. We provided tools and encouraged people to take apart their broken devices, laying them out and photographing them. I wanted people to have a visceral experience of the incredible forms inside these things. I made a set of temporary tattoos so that you can wear them on your skin. This idea was the inside coming outside—the black box revealing what is inside for people.

Through installation, video, and digital media works, New York–based artist **Penelope Umbrico** *(American, born 1957) utilizes photo-sharing and consumer-to-consumer websites as an expansive archive to explore the production and consumption of images, often through radical methods of appropriation. Her work navigates between producer and consumer, local and global, the individual and the collective, with attention to the technologies that are produced by (and produce) these forces. Umbrico's work has been exhibited at MoMA PS1 and the Museum of Modern Art, New York; MASS MoCA, North Adams; San Francisco Museum of Modern Art; and the Musée des beaux-arts du Locle, Switzerland, among others, and is represented in museum collections around the world. She has received numerous awards, including a Guggenheim Fellowship, Sharpe-Walentas Studio Grant, Smithsonian Artist Research Fellowship, New York Foundation for the Arts Fellowship, and Anonymous Was a Woman Award. Her monographs have been published by Aperture and RVB Books.*

OPPOSITE
Penelope Umbrico, *Monument (News)*, 2018, forty-two broken LCD TVs and computer monitors, live cable stream. Installation at BRIC Arts Media, Brooklyn, 2018. Courtesy of the artist

Notes

The Exhibition's Metadata (pages 11–21)

1 Arofan Gregory, Pascal Heus, and Jostein Ryssevik, "Metadata," in *Building on Progress: Expanding the Research Infrastructure for the Social, Economic, and Behavioral Sciences*, ed. German Data Forum (RatSWD) (Opladen, Germany: Budrich UniPress, 2010), 487.

2 Daniel Rubinstein and Katrina Sluis, "Notes on the Margins of Metadata: Concerning the Undesirability of the Digital Image," *Photographies* 6, no. 1 (2013): 151.

3 Estelle Blaschke, "From Microform to the Drawing Bot: The Photographic Image as Data," *Grey Room*, no. 75 (Spring 2019): 66.

4 Blashcke, "From Microform to the Drawing Bot," 65.

5 Anne J. Gilliland, "Setting the Stage," in *Introduction to Metadata*, ed. Murtha Baca (Los Angeles: Getty Research Institute, 2016).

6 Allan Sekula, "The Body and the Archive," *October* 39 (Winter 1986): 56.

7 Sekula, "Body and the Archive," 56.

8 John Tagg, "The Archiving Machine; or, The Camera and the Filing Cabinet," *Grey Room*, no. 47 (Spring 2012): 33.

9 Michel Foucault, *Archaeology of Knowledge and the Discourse on Language*, trans. A. M. Sheridan Smith (New York: Pantheon Books, 1971), 129–30.

10 Geoffrey Batchen, "Ectoplasm: Photography in the Digital Age," in *Over Exposed: Essays on Contemporary Photography*, ed. Carol Squires (New York: New Press, 2000), 19.

11 Batchen, "Ectoplasm," 19.

12 Joanna Zylinska, "Introduction," in *Photomediations: A Reader*, ed. Kamila Kuc, Joanna Zylinska, Jonathan Shaw, Ross Varney, and Michael Wamposzyc (London: Open Humanities Press, 2016), 13.

13 Zylinska, "Introduction," 13.

14 Zylinska, "Introduction," 11.

15 See the interview with Lazarus and Feser in this catalog.

16 László Moholy-Nagy, "Production-Reproduction," in *Moholy-Nagy*, ed. Krisztina Passuth (New York: Thames and Hudson, 1985), 289.

17 Martin Lister, "Introduction," in *The Digital Image in Photographic Culture*, ed. Martin Lister (New York: Routledge, 2013), 8.

18 "The Post-Photographic Condition. Le Mois de la Photo à Montréal," *anti-utopias*, September 16, 2015, https://anti-utopias.com/newswire/post-photographic-condition/.

19 Lev Monovich, "Metadata, Mon Amour," 2002, http://manovich.net/content/04-projects/039-metadata-mon-amour/36_article_2002.pdf, 1–2.

20 Manovich, "Metadata, Mon Amour," 15.

21 Tim O'Reilly, "What Is Web 2.0: Design Patterns and Business Models for the Next Generation of Software," *O'Reilly*, September 30, 2005, https://www.oreilly.com/pub/a/web2/archive/what-is-web-20.html.

22 Jim Edwards, "Planet Selfie: We're Now Posting a Staggering 1.8 Billion Photos Every Day," *Business Insider*, May 28, 2014, https://www.businessinsider.com/were-now-posting-a-staggering-18-billion-photos-to-social-media-every-day-2014-5.

23 Stephen Heyman, "Photos, Photos Everywhere," *The New York Times*, July 29, 2015, https://www.nytimes.com/2015/07/23/arts/international/photos-photos-everywhere.html.

24 See Giorgio Agamben, *What Is An Apparatus? and Other Essays*, trans. David Kishik and Stefan Pedatella (Stanford: Stanford University Press, 2009), 19–20.

25 Susan Sontag, *Regarding the Pain of Others* (New York: Picador, 2003), 117.

26 Daniel Rubinstein and Katrina Sluis, "A Life More Photographic: Mapping the Networked Image," *Photographies* 1, no. 1 (2008): 9.

27 Michelle Henning, "Image Flow: Photography on Tap," *Photographies* 11, nos. 2–3 (2018): 135.

28 Daniel Rubinstein and Katrina Sluis, "Notes on the Margins of Metadata: Concerning the Undesirability of the Digital Image," *Photographies* 6, no. 1 (2013): 152.

29 Ingrid Hoelzl and Rémi Marie, *Softimage: Towards a New Theory of the Digital Image* (Bristol: Intellect, 2015), 3–4.

30 Rubinstein and Sluis, "Notes on the Margins of Metadata," 153.

31 Rubinstein and Sluis, "Notes on the Margins of Metadata," 156.

32 Lilly Lulay, "Writing Tools," accessed January 12, 2021, https://lillylulay.de/writing-tools.

33 Matteo Pasquinelli, "Metadata Society," in *Posthuman Glossary*, ed. Rosi Braidotti and Maria Hlavajova (London: Bloomsbury, 2018), 253–54.

34 Pasquinelli, "Metadata Society," 253–54.

35 Shoshana Zuboff, *The Age of Surveillance Capitalism: The Fight for a Human Future at the New Frontier of Power* (New York: PublicAffairs, 2019), 271.

36 Zuboff, *Age of Surveillance Capitalism*, 8.

37 Zuboff, *Age of Surveillance Capitalism*, 9.

38 For the quote by General Hayden, view "The Johns Hopkins Foreign Affairs Symposium Presents: The Price of Privacy: Re-Evaluating the NSA," Johns Hopkins University, April 7, 2014, video, 1:14:34, https://youtu.be/kV2HDM86XgI. On signature drone strikes, see Kate Crawford, *The Atlas of AI: Power, Politics, and the Planetary Costs of Artificial Intelligence* (New Haven: Yale University Press, 2021), 204.

39 Harun Farocki, "Phantom Images," in *PUBLIC*, no. 29 (January 2004): 17.

40 Farocki, "Phantom Images," 16. Farocki cites Paul Virilio's book, *War and Cinema: The Logistics of Perception*, trans. Patrick Camiller (London: Verso, 1989).

41 See Trevor Paglen and Rebecca Solnit, *Invisible: Covert Operations and Classified Landscapes* (New York: Aperture, 2010); and Trevor Paglen, *Blank Spots on the Map: The Dark Geography of the Pentagon's Secret World* (New York: New American Library, 2014).

42 Luke Skrebowski, "Resistance at a Moment of Danger: On Trevor Paglen's Recent Work," in *Trevor Paglen: Sites Unseen*, ed. John P. Jacob and Luke Skrebowski (Washington, DC: Smithsonian American Art Museum; London: D Giles, 2018), 142.

43 Trevor Paglen, "Invisible Images (Your Pictures Are Looking at You)," *The New Inquiry*, December 8, 2016, https://thenewinquiry.com/invisible-images-your-pictures-are-looking-at-you/.

44 Paglen, "Invisible Images."

45 Joy Buolamwini, "How I'm fighting bias in algorithms," *TedxBeaconStreet*, November 2016, video, 8:35, https://www.ted.com/talks/joy_buolamwini_how_i_m_fighting_bias_in_algorithms.

46 Steve Lohr, "Facial Recognition Software Is Accurate, if You're a White Guy," *The New York Times*, February 9, 2018, https://www.nytimes.com/2018/02/09/technology/facial-recognition-race-artificial-intelligence.html.

47 Joy Buolamwini, "When the Robot Doesn't See Dark Skin," *New York Times*, June 21, 2018, https://www.nytimes.com/2018/06/21/opinion/facial-analysis-technology-bias.html.

48 Quote by Rafael Lozano-Hemmer from Julie Schweitert Collazo, "An Artwork Forces Us to Face Mexico's Disappeared Students," *Hyperallergic*, August 7, 2015, https://hyperallergic.com/228317/an-artwork-forces-us-to-face-mexicos-disappeared-students/.

The Photo Is the Metadata (pages 22–27)

1 *Oxford English Dictionary Online*, s.v. "amateur," accessed November 2, 2018.

2 "Our Navy Synopsis," IMDb, accessed February 13, 2021, https://www.imdb.com/title/tt0160618/plotsummary?ref_=tt_stry_pl#synopsis.

3 Joseph Wechsberg, "Whistling in the Darkroom," *The New Yorker*, November 10, 1956, 82.

4 Wechsberg, "Whistling in the Darkroom," 88.

5 The additive color process uses traditional black-and-white film and it achieves the appearance of color through "optical rather than chemical means." Interview with Leopold Godowsky, April 17, 1972, Box 1, Folder 4, Lawrence Bachmann Papers, Rare Books, Special Collections, and Preservation, River Campus Libraries, University of Rochester, Rochester, New York. In the Prizma Color process used to produce Our Navy, the film strip would be hand-tinted, with the colors of the individual frames alternating between "orange-red" and "blue-green." Flickering rapidly on screen, the colors blur together. Most often, however, additive color systems required the use of multiple projectors, each equipped with a color filter. When the multiple beams of light were superimposed on the screen, they were supposed to add up to a full-spectrum image.

6 Wechsberg, "Whistling in the Darkroom," 86.

7 Esther Leslie, *Synthetic Worlds: Nature, Art and the Chemical Industry* (London: Reaktion Books, 2005).

8 Wechsberg, "Whistling in the Darkroom," 90. Johannes Brahms's Symphony No. 1 in C Minor debuted in Karlsruhe, Germany, in 1876.

9 Kodak print advertisements, 1937, George Eastman Legacy Collection, George Eastman Museum, Rochester, New York.

10 Karl Marx, "Difference Between the Democritean and Epicurean Philosophy of Nature," in *Karl Marx and Frederick Engels: Collected Works*, vol. 1, *Marx: 1835–1843* (London: Lawrence & Wishart, 1975), 49.

11 Marx, "The Difference Between the Democritean and Epicurean Philosophy of Nature," 72.

12 Susan Buck-Morss, *Dreamworld and Catastrophe: The Passing of Mass Utopia in East and West* (Cambridge, MA: MIT Press, 2002).

13 Lauren Berlant, *Cruel Optimism* (Durham: Duke University Press, 2011).

14 Hannah Arendt, *Origins of Totalitarianism* (New York: Harcourt, 1976), xiv.

Notes

Interview with Mohsen Azar (pages 30–39)

1 Susan Sontag, *Regarding the Pain of Others* (New York: Picador, 2003), 125–26.

Joy Buolamwini (pages 70–73)

1 Kashmir Hill, "Wrongly Accused by an Algorithm," *New York Times*, June 24, 2020.

2 Algorithmic Justice League, "Our Mission," https://www.ajl.org/about.